Foreheads of the Dead

An Anthropological View of Kalabari Ancestral Screens

NIGEL BARLEY

Published for the National Museum of African Art
by the Smithsonian Institution Press

Washington, D.C., and London

This book is published in conjunction with the exhibition *Kalabari Ancestral Screens: Levels of Meaning,* organized by the National Museum of African Art.

November 11, 1988–January 29, 1989

Library of Congress Cataloguing-in-Publication Data
Barley, Nigel.
 Foreheads of the dead.
 Bibliography: p.
 1. Ijo (African people)—Exhibitions. 2. Sculpture, Ijo
(African people)—Exhibitions. 3. Ijo (African people)—
Religion—Exhibitions. I. Title.
DT515.45.I35B37 1988 306'.089963 88–26395
ISBN 0–87474–245–5 (alk. paper)

Acid-free paper is used in this publication.

COVER: Ancestral Screen (*Duein Fubara*), Kalabari group, Ijaw peoples, Nigeria (cat. no. 8)

PHOTOGRAPH CREDITS
Glasgow Museums and Art Galleries: cat. no. 10
The Minneapolis Institute of Arts: cat. no. 13
Pitt Rivers Museum, University of Oxford: cat. nos. 11–12
Trustees of the British Museum: cat. nos. 1–9, figs. 1–20
 (figs. 1, 3–4, 8–12, 17–20 by Nigel Barley)

Editor: Dean Trackman
Designer: Christopher Jones

Contents

Foreword

Along the byways of African art studies is the history of the preservation of a fascinating group of objects called *duein fubara*, or "foreheads of the dead." These ancestral screens, created by the Kalabari of the eastern Niger Delta, are the subject of both this book by British anthropologist Nigel Barley and an exhibition at the National Museum of African Art.

The fortuitous presence among the Kalabari of the British colonial officer P. Amaury Talbot, who took an exceptional interest in Kalabari culture, resulted about 1916 in his acquiring all but one of the exhibited screens. The heads of the Kalabari trading houses, responsible for the ancestral shrines of which the screens were a part, placed the screens under Talbot's protection to save them from almost certain destruction by a fundamentalist Christian cult. Talbot deposited the screens without full documentation in the British Museum in London and the Pitt Rivers Museum in Oxford. Those in the British Museum were not catalogued until 1950—five years after Talbot's death—when William Fagg took on that task. In 1974, one Talbot screen entered the collection of the Minneapolis Institute of Arts.

Nigel Barley has written an admirable essay that sets the screens in their historical and cultural contexts, aiding our understanding of the screens as important objects among the Kalabari. Whether the screens should be viewed as works of art is another concern of this book. On the basis of his fieldwork and that of other scholars, Barley firmly believes that the ancestral screens are not works of art to the Kalabari. They do seem, however, to be the product of a special skill; as Barley notes, the Pokia family of Ifoko was recognized as having the best woodcarvers of the screens. These objects now appeal to a modern Western sensibility that has no difficulty in finding them a form of expression that can comfortably be called art.

Whether or not they are perceived as art, the Kalabari ancestral screens are worth our attention as major products of an African society. Although the screens now in Western museums have been frozen in time, they are part of a tradition that has continued to the present day.

ROY SIEBER
Associate Director
National Museum of African Art

Acknowledgments

Thanks are due to the *amanyanabo* of Kalabari and the Buguma council of chiefs for permission to carry out research on the Kalabari ancestral screens. Important informants were Chief Anthony Abo Briggs of Abonnema and Mr. Bliss Iyalla of Bakana, as well as numerous house heads in Buguma. Dr. Tonye Erekosima of the University of Port Harcourt was kind enough to comment at length on an early draft; great benefit has derived from his observations.

The Director and Trustees of the British Museum generously allowed me the time to conduct research in Kalabari. I am grateful to the Smithsonian Institution's National Museum of African Art for enabling me to publish the results of my work. Thanks are due to His Excellency the Nigerian High Commissioner in London, Mr. George Dove-Edwin, for his support in gaining permission for me to conduct fieldwork. This book was produced in conjunction with an exhibition at the National Museum of African Art, *Kalabari Ancestral Screens: Levels of Meaning*. The British Museum, the Pitt Rivers Museum, and the Glasgow Museums and Art Galleries graciously lent their ancestral screens for the exhibition.

A special debt of gratitude is owed to Professor Robin Horton of the Department of Religious Studies, University of Port Harcourt. No researcher could begin to write about Kalabari sculptural traditions without first referring to his published works. In addition, Professor Horton's generosity of time and information, good fellowship, and patient guidance in the field have greatly influenced this publication. The information presented here has either derived from his own research or benefited extensively from his explanations and interpretations. Errors remain my own.

Introduction

Exhibitions of ethnographic objects vary enormously in style and scope. Many start from the assumption that the ethnographic world is divided neatly into discrete "tribes" without overlap and each possessed of a homogenous culture. From such a perspective, each exhibition features a single tribe, for the tribe and the museum exhibition are instinctively felt to be made for each other. Indeed, so they are, for both derive from very European ideas about the relations of ethnicity, culture, race, and language—ideas that are not appropriate to conditions in other parts of the world. Elsewhere, the assumption that political, linguistic, and cultural boundaries coincide is very far from confirmed. A crucial lack of fit between them is still apparent in many areas, though Westerners, including anthropologists, have created tribes wherever they went. Their notions have often imposed themselves on other peoples, who now defiantly maintain an identity that emerged from European misunderstanding.

The Kalabari have developed their own notions of identity and determinedly created for themselves an ethnicity from elements drawn from many sources. Part of the genius of Kalabari culture consists of its ability to ingest and transform the alien by a process of reinterpretation. The objects shown in this book are merely part of such a process.

Some exhibitions focus on the category of "art." It may well be an inappropriate way of considering the material productions of other peoples, for it is a category deeply rooted in Western history and culture. In many of the cultures in which anthropologists have worked, the category of art does not correspond in any simple way to the categories that local people use to understand their own material objects. Museums are special places that impose particular culture-bound interpretations on all they contain. When an object is exhibited in a museum, it implies that the object is significant. For Westerners, the significance of museum objects often lies in their aesthetic and artistic value. Such an approach to the Kalabari ancestral screens is indeed inevitable, since

they are figurative and are bounded by a frame, both of which are powerful cues for artistic interpretation in our Western tradition. Yet, this is not the approach of the Kalabari to these objects. The fact that to consider objects from other cultures as art confers status and prestige upon them does not defuse charges of ethnocentrism. Indeed, it is part of a curious Western notion that the possession of art is the measure of a culture, a yardstick of relative worth.

It is not to be wondered at, then, that many exhibitions throw up their hands in despair and seize the easy option of "themes": mother and child, the ancestors, female beauty. Almost any general topic will serve to bring a collection of objects together, and as every curator knows, exhibitions depend on objects.

The present exhibition at the National Museum of African Art and this publication take a somewhat different tack and focus on a single class of images, the *duein fubara*, "foreheads of the dead," conventionally known as the Kalabari ancestral screens. These striking and evocative works were made by Kalabari craftsmen of the trading city-state of New Calabar in southern Nigeria. Memorials to deceased heads of trading houses, they were kept in the meetinghouses of the group. They are the product of a particular time and place, located within a network of cultural and historical conditions. *Duein fubara* constitute a category of things distinguished by the people themselves, a category concerning which they have strong feelings rather different from the reflective responses of Western art. For through their very particular position, these screens touch chords that would not be out of place in a "thematic" exhibition: sacred and secular power, the structuring of time, the notion of self and other, public and private identity.

Although they have long been known to the West and indeed have inspired some Western artists,[1] the origin and meaning of these screens remain something of an enigma, an enigma that is the subject of this book. It is hoped that their exploration may lead to a revision of some of the easy orthodoxies of the interpretation of African "art." For it is often forgotten that interpretation is not an exclusive concern of the West. The images produced by the West are themselves subjected to the withering gaze of the non-Western world, and it is not possible to predict what paths these local reprocessings may follow. We now live in a world where other cultures use television programs such as *Dallas* and *Dynasty* to understand their local missionaries. The Kalabari were one of the first peoples in Africa to experience and cope with the onslaught of the West.

The Kalabari ancestral screens now in Western museums, with the exception of catalogue number 10, arrived in the West as a result of a minor incident in the everyday business of the British Empire during the First World War. Between 1914 and 1916, these ancestral screens were acquired by P. Amaury Talbot, a British administrative

officer in the Degema division of southern Nigeria, and were later bestowed upon English museums. The circumstances have been described by Oelmann (1979), following Talbot (1916).

At that time, the Kalabari settlements of Abonnema and Bakana were under the influence of the fundamentalist Christian leader Garrick Braide. Braide was from Bakana, but his influence in the town of Abonnema was so great that he was able to destroy the temple of Owamekaso, the national deity, there and build a church on the spot. His sway extended to other Kalabari settlements such as Ifoko, but because of traditional animosity between Bakana and Buguma, the principal Kalabari city, the latter town resisted his influence.[2] It is clear that the chiefs gave the screens to Talbot as an alternative to their destruction. They did so at some personal risk from frustrated iconoclasts.

Braide is said to have engaged in various excesses, such as charging disciples to enter their names in an exercise book of salvation and selling his bath water as medicine.[3] Owing to the disorder he caused and the anti-British tone of some of his pronouncements, Talbot finally arrested him, but he was released soon afterward. As befits such a controversial figure, opinions about his fate are divided. Local tradition has him dying rapidly of "blue boil," a venereal disease, or being struck by lightening while in a boat on the way to Bonny. The latter version is in accord with his claim to be a reincarnation of the prophet Elijah, who ascended to heaven in a whirlwind.[4] His tomb is in Bakana, and the church he founded remains important.[5]

It is perhaps fitting that these sculptures came to the West as part of a wider movement in Kalabari culture. Even in matters of imported religion, the Kalabari were never content to simply accept that which was offered from outside. They were active transformers.

Foreheads of the Dead:

An Anthropological View of Kalabari Ancestral Screens

The Kalabari are a part of the larger Ijaw-speaking group of the Niger Delta. The latter includes the polities of Bonny and Okrika to the east of Kalabari and Nembe to the west. Within this linguistic grouping, the Kalabari have come to regard themselves as members of a separate entity, numbering some five hundred thousand persons. Their sense of ethnic distinctiveness rests on their different political structure under a single king, or *amanyanabo*, their former economic dependence on foreign trade, and the rich cultural life that they have developed. Traditionally, they have inhabited the creeks, mangrove swamps, and islands of what is now Rivers State, Nigeria.[6] Originally, they were inland fishermen, selling smoked or dried fish to the inland peoples and cultivating the scarce dry land of the area.[7] Principal trade links were with peoples upstream (Horton 1969). Marriage took place mainly within the village. It is a style of life still led today by many of the Ijaw peoples of the area. Nowadays, however, numerous Kalabari have moved to the city of Port Harcourt, where they are active in commerce and government. They still return frequently to their origins in the such settlements as Abonnema, Buguma, and Bakana, especially on weekends. Many have converted to Christianity as they become more involved in the life of the modern Nigerian state, yet links with the past are strong. The shrines of ancestors and water spirits still command allegiance. A major masquerade in a Kalabari town crowds the speedboats leaving Port Harcourt.

Kalabari today is literally a backwater. From the late fifteenth to the mid-nineteenth century, however, the Kalabari were pivotal middlemen between the European adventurers and traders of the coast and the inland peoples of the West African interior. At that time, the principal Kalabari settlement was the city-state of New Calabar, or Owame. In the late nineteenth century, the city-state exploded in civil war and fragmented into the Kalabari townships of today. Apart from the town of New Calabar itself, the state comprised associated villages such as Ifoko and Tombia,

plantations on dry land where crops could be cultivated and slaves employed, and large areas occupied by non-Kalabari where it alone possessed the right to trade. Periodic adjustments of these areas of exclusivity were the chief motive for war in the Niger Delta and, indeed, do much to explain the present location of Kalabari settlements as they maneuvered to cut off rivals from essential sources of supply. For some 450 years after the first contacts with Europeans, New Calabar seems to have been a major trading settlement.

Our first information on the area comes from Duarte Pacheco Pereira's *Esmeraldo de Situ Orbis,* the chronicle of a journey along the west coast of Africa, probably at the end of the fifteenth century (Pacheco Pereira 1937). It is difficult to tell whether New Calabar is specifically included in the settlements "up the river" that are engaged in trade,[8] but we learn that the "Jos" (Ijaw) are already heavily involved in slave dealing and avidly seek the copper bracelets known as manillas, which are still displayed before ancestral shrines. Kalabari seem to be described as trading with Europeans through Bonny middlemen on the coast.[9] Even in later times, large ships seldom went far up the New Calabar River, finding Ifoko a more salubrious place to moor. Although pepper and ivory were important commodities in early times, it was the trade in slaves that brought an upsurge of wealth in the seventeenth and eighteenth centuries. It was a trade that transformed the fishing village into the city-state.

In Olfert Dapper's *Description de l'Afrique,* published in 1686, there is explicit mention of Fokke (Ifoko, where the *duein fubara* were probably made). The town was known to the Dutch as Wyn-dorp, "Wine Village," because of its plentiful palm wine. The book also includes the first description of New Calabar, a palisaded village "where the Dutch do most of their business."

This description is fleshed out by Jean Barbot's 1746 chronicle, which draws on older information. New Calabar is said to contain 309 houses. From a passage comparing the town of Bonny with New Calabar, it is evident that the Atlantic trade was in full swing at this time:

> It [Bonny] is well peopled with *Blacks,* who employ themselves in trade, and some at fishing, like those of *New Calabar* town, in the inland country, by means of long and large canoos, some sixty foot long and seven broad, rowed by sixteen, eighteen or twenty paddlers carrying *European* goods and fish to the upland *Blacks;* and bring down to their respective towns, in exchange, a vast number of slaves, of all sexes and ages, and some large elephants teeth, to supply the Europeans trading in that river. Several of those *Blacks* act therein as factors, or brokers, either for their own countrymen, or for the *Europeans* who are often obliged to trust them with their goods, to attend the upper markets, and purchase slaves for them.

After the slave trade was ended in the second half of the nineteenth century, other goods, primarily palm oil for making soap and lubricants in Europe, began to be exported in what was known as the legitimate trade.[10] This attracted a new breed of adventurer, the so-called palm-oil ruffians, who were scarcely less unruly than the slavers they replaced.[11] Little by little, the Kalabari lost their position as traders. The independent city-state was absorbed by the British into the Oil Rivers Protectorate in 1889, the Niger Coast Protectorate in 1893, and finally the colony of Nigeria in 1906. With political change, Europeans swiftly penetrated to the interior, and trade moved to the more convenient locations of Lagos and Port Harcourt. The Kalabari lost their middleman role.[12]

Trade and the Transformation of Society

The slave trade in Africa has a lengthy and complex history (Curtin 1971). It was transformed over the years from an internal, domestic slavery to a major export industry. We know from the early chroniclers that the export of slaves was already in operation in the late fifteenth century (Jones 1963, 33). Initially, markets were to be found further west along the coast in Senegambia and Ghana. It was the development of colonies in the Americas, however, that generated a seemingly insatiable demand for labor from the inland areas of the Niger Delta. The Kalabari were active intermediaries in the slave trade, bringing slaves—principally Igbo and Ibibio—from the upriver markets to the coast where they could either be sold to Europeans or absorbed directly into Kalabari society.[13] In return, they received European imports, notably brassware, alcohol, and firearms that could be resold for a profit to inland peoples. Normally, goods were advanced by the European traders on credit and at high prices[14] to the heads of trading houses. House heads would then advance goods on similar terms to members of their own houses, who would go off on speculative trading expeditions to the interior.

The area became a hothouse of fiercely competitive, individualistic capitalism. Debt was a chronic difficulty that plagued trading contacts in the Niger Delta, occasionally leading to the diplomatic or military intervention of the British consul. The history of the system has been examined in detail by Jones (1963). In Kalabari, trade for Europeans seems to have been less involved than in some other trading polities. In the Benin Kingdom, for example, Europeans were obliged to make up a balanced mix of goods to offer for sale (Ryder 1969). Nevertheless, commerce was vexed by a series of imposts payable to the king, "juju" men,[15] house heads, and agents. Payments had to be made to open and close trade, and "dash," or gifts, of fixed amounts had to be given. Traders continually railed against taxes imposed by the houses. When resident traders replaced captains of ships as agents, a new payment

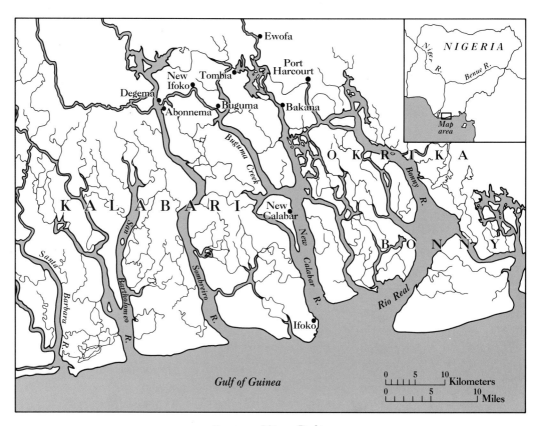

Eastern Niger Delta

called "handshake" quickly arose to compensate for lost "comey," the payment usually made when a ship arrived in a river to trade. The actual goods to be traded were usually exchanged at fixed prices, which led to endless disputes about quality. The history of trade in the Niger Delta is one of endemic dispute and occasional violence.

The major trading group was the corporate canoe house. The canoes were the descendants of those large vessels that impressed early chroniclers. These were not the ostentatious, multistory vessels seen at present-day Kalabari festivals, but large dugouts with cannons mounted fore and aft. Canoes coordinated their activities when out of sight of each other by means of signal drums. One of the expected functions of a house chief was to act as war leader and captain of the canoe, which was placed at the service of the king in times of national emergency. The effect of cannon fire on a town of wood and mud houses was devastating, as the Kalabari quickly learned from acts of foreign intervention. Canoe raids came to play a major part in battle in the Niger Delta.

Any man capable of establishing and maintaining a thirty-man war canoe was free

to set up a house. The possession of a war canoe thus entitled a man to participate in the public assembly that directed judicial and governmental activities. In practice, of course, he was reliant for credit and support on a house head of established stature and could not hope to set up his own branch house without years of faithful and energetic trading activity on behalf of his leader's main house. The leader would exact "topping," a levy on the trade, up to the time when the man was able to set up his own house. After that, he would be free of such an obligation, but he would still be bound politically to his former house. The degree of political freedom exercised by the head of a branch house depended upon his personal wealth and following and the quality of leadership exercised by the head of the main house. If successful in trade, such a man might even aspire to take over the parent house. Weakness on the part of the main house leader, however, could lead to the dissolution of the group of houses, as occurred with the Don Pedro house (see cat. no. 13). Its three component houses had to attach themselves to more powerful houses in order to survive.

Competition between houses was fierce and occasionally erupted in open fighting, as in the conflict of the 1880s that led to the dissolution of the city-state of New Calabar and the founding of the current settlements.[16] Such rivalry also strengthened the authority of house heads. They consolidated their power by creating a town council that replaced the village assembly of all adult males. It might also be said that it reduced their ability to negotiate with European traders, who found it easy to play one house against another.

Dealing in slaves created the wealth that primed the trading machine that was the Kalabari house, but it also did much more. Slaves helped reconstitute the house itself. It has been estimated that for over a hundred years the number of foreign slaves absorbed into the trading houses equalled the number of freeborn Kalabari (Horton 1969, 55). In a society dependent on trade in an area of constant warfare, supporters were in and of themselves wealth and power. Houses, therefore, would be eager to attract new members. Slaves were adopted into the family of a house head. On occasion, slaves might be transferred between houses. Thus, after fighting between Korome and Amachree, the former house was punished by being obliged to transfer one of its leaders and his followers to Amachree (Jones 1963, 137). Members might also be sold off to other houses if they were irksome or if the house needed money.

Traditional Kalabari society consisted of descent groups, or *wari*. Depending on the type of marriage entered into, affiliation could be either through mother or the father. If a high brideprice was paid—called *eya* marriage—offspring would belong to the father's group. If a low brideprice was paid—called *egwa* marriage—they would belong to that of the mother.[17]

In the trading polity of New Calabar, the term *wari* was retained, but it applied to

the canoe house. The process by which a canoe house developed has been studied in detail by Jones (1963). New slaves, normally children, were allocated to a "mother," one of the numerous wives of a house head. She was responsible for feeding and caring for them. House heads depended on dynamic and authoritative wives. Such powerful women represented one of the major lines along which a house could divide. It would be in the interests of the natural and adopted sons of such a woman to cooperate in expanding the wealth and population of the subhousehold until such time as it could split off as a branch house under the ablest male. The other sons would then expect the new leader's help in establishing their own branch houses. A house head might well cooperate in such aims, since he would often find it better to create new allies in the council of chiefs rather than rivals within his own house. An ambitious and energetic slave could rise to replace his "father" as head of the main house, even in preference to the house head's true sons.

Although house heads had great power and commanded large resources, they were dependent on their followers. A leader who failed to perform well could not hope to last long. For example, during the dispute for the succession to Amachree III, the Kalabari king, the candidate from the Barboy house, Alambo, failed to do well militarily in an action against the Okarki people. He was promptly toppled and replaced within the house by Will Braide. Alambo's rival from another house was made king. According to Horton (1969, 49), "The canoe house was a relentless sorting machine, crushing the ill endowed but propelling the more dynamic, intelligent personalities to the top of the social scale."

In theory, a man's slave origins would never be alluded to. They would never be forgotten, however, and might be raised at a time of dispute. Two institutions functioned to inculcate Ijaw cultural traditions and test those who sought to absorb them. Both are important for understanding the iconography of the ancestral screens.

First was the Ekine society, also known as Sekiapu, "the dancers" (Horton 1963, 1966). This masquerade association organized performances where masked dancers embodied the water spirits who controlled the marshes and creeks.[18] To be a member of Ekine was to gain enormous respect and prestige. To be a major trader without Ekine membership was to be a parvenu (Horton 1969, 54). In the Niger Delta, status and prosperity were mutually reinforcing. Social success brought with it greater protection and profit. In the local pidgin, one meaning of the word *trust* was "goods given on credit."

The Ekine society was theoretically open to all. A new member had to be proposed by a sponsor who was impressed by his dancing ability. Only minimal payments to the society would have to be made at this stage. He would hope, however, to progress from the junior grade to the senior grade, which could only be achieved by

successfully performing one of the masquerades that involved pointing out local shrines in response to the calls of the drummer. Successful performance in a major Ekine masquerade set a man at the pinnacle of Kalabari achievement. It involved mastery of dancing, the Ijaw tongue, and the drum phrases that echoed the tone patterns of language, as well as knowledge of the sites of shrines—in short, formidable feats of memory and concentration subsumed within an overarching ethic of effortless stylistic elegance (Horton 1966). It was the ultimate test of enculturation. Success brought lasting fame and failure brought shame and dishonor. A failed dancer was publicly unmasked and disgraced (Horton 1969, 53). Suicide might well follow a bungled Ekine performance.

The second institution involved in inculcating Ijaw cultural traditions was Koronogbo (Horton 1969, 54). It was the inner group of the Periapu Ogbo, the warriors' head-hunting society. Members were said to roam the town at night and challenge those they met. Those unable to reply in a good Kalabari accent could be killed.

Kalabari society may be briefly characterized, then, in the following terms. It was fluid and competitive and dealt in achieved rather than ascribed success. Success could bring enormous wealth and power. Failure brought miserable slavery and even death. Unsuccessful slaves could always be sold to Europeans and effectively deported, though according to official ideology any slave who had undergone formal adoption into a house had the same basic rights as a freeborn member. In theory, anyone could rise to the top through effort and entrepreneurial zeal, even to the point of aspiring to the kingship. New Calabar was dedicated to business activity and required loyalty to the trading house. It worshiped commercial success. It ingested a huge number of immigrants yet remained doggedly Kalabari in culture and language.

These values—evocative of many of the basic themes of American culture—have not passed unmarked in the sculptural traditions of the Kalabari, especially in the ancestral screens.

Kalabari Woodcarving

Horton (1965a, 8) makes the point that woodcarving is not prominent in Kalabari everyday social life. It is found principally in the shrines of spiritual beings, where a carving is referred to as *oru fubara*, "the forehead of the spirit." The ancestral screens are called *duein fubara*, "the foreheads of the dead."

To understand the term *duein fubara*, it is necessary to outline Kalabari notions of the person, especially the spiritual components of personhood.[19] Like many other West Africa peoples, the Kalabari regard the human individual as the place of interaction of a number of spiritual forces and entities. Foremost components of humanity are *so* and *tamuno*. *So* can be crudely rendered as "destiny" or "will," a concept invoked in

explanations of typical behavior.[20] *Tamuno* can be glossed as "life-force," a concept involving creation and destruction.[21] It is far from clear that these are to be viewed as distinct entities—rather they are overlapping principles that may be appealed to in different contexts. It is the interaction of *so* or *tamuno* with other spiritual forces, primarily ancestors, heroes, and water spirits, that explains the differing fates of apparently similar men.

Ritual life in Kalabari is structured by a grand cycle that assigns various periods to each of the three major types of spiritual beings (Horton 1960a). The cycle may take as long as fifteen years to run from beginning to end. During each period the appropriate spiritual beings are summoned and enter into relations with mankind. At any particular time, one class of beings is the focus of activity, yet there is always a feeling that balance must be maintained between all spiritual entities. Thus, for example, although water spirits are honored during the period of masquerades, this occurs under the tutelage of the national deity, Owamekaso, and Ekineba, the heroine who inaugurated masquerading. The night before their masquerade performance, members of the Ekine society move in a procession around the town and visit the main ancestral shrines. A particular mask will be placed before the ancestral shrine of the man associated with it (fig. 1). Although the water spirits are momentarily dominant, there is a sense in which all three classes of beings are always in a balanced relationship.

In function, and to a lesser degree in form, carved images may be divided into the same three categories of ancestors, heroes, and water spirits. Horton has discussed this partition of the universe in a number of publications.[22] The water spirits control creeks and waters, weather, and fish. Their shrines are in and about the creeks. The heroes are responsible for culture and innovations in life-style. Their shrines are located on ground that belongs to the whole community. Ancestral spirits are responsible for the well-being of their descendants. Their shrines are located in the houses of these descendants.[23]

In the complex relations that link men and spiritual beings, there is a third term of importance: *teme*, "fixed spirit." Every individual object, person, and plant has its own *teme* that controls its behavior "as a steersman controls his canoe" (Horton 1965a, 4). On death, *teme* is held to leave the body. In the bodies of the living, *teme* is located primarily in the forehead of the individual. In the powerful masquerades that involve the possession of the wearer by the spirit, possession is attributed to the *teme* of the water spirit. These masks are worn on the head of the carrier, where his own *teme* resides. Individuals may, however, also become possessed by the *teme* of a deceased ancestor, notably while engaged in making offerings to the *duein fubara*.

It is through carved images alone that men are able to locate and control spiritual beings. As Horton (1965a, 8) explains: "When Kalabari feel that someone is acting

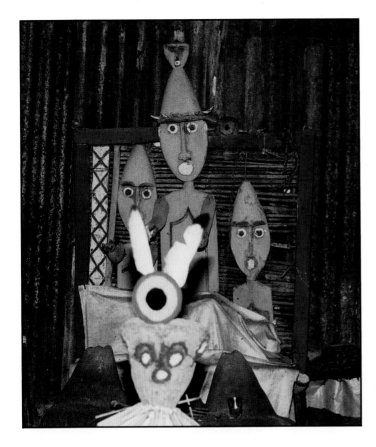

Fig. 1. Ngbula masquerade headdress in front of an ancestral screen that displays the same headdress, 1987.

over-arrogantly, they may ask him: 'Are you a spirit without a sculpture?'—meaning, 'Do you think we have nothing through which we can control you?'" The relationship between a spirit and its sculpture is explained as being similar to that between a person and his name; a sculpture may indeed be said to be the name of a spirit.[24]

Kalabari notions of the function of wooden images enter, then, into a view of human destiny and control that has wider currency through West Africa. Other groups have long been known to associate particular aspects of personhood with specific parts of the body, just as we in the West have linked courage and love with the heart. Such Kalabari notions are superficially comparable to the "cult of the hand" of Benin and Igboland, whereby individuals may control the sphere of personal achievement through a sculpture that regulates that part of the body (Boston 1977; Ben-Amos 1980), or the control among the Urhobo of what we would regard as aspects of the personality through a multiplicity of sculptural forms (Foss 1975).

It is in keeping with the Kalabari view of images as tools by which spirits may be localized and made subject to human entreaty and control that they are not major

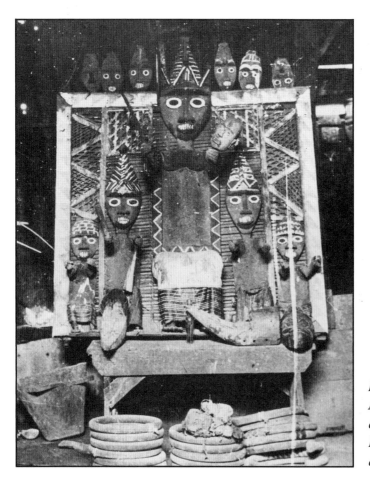

*Fig. 2. Ancestral shrine of
Amachree I, Buguma,
c. 1920. (Photograph by
Mr. Chadwick, a British
administrative officer)*

objects of *aesthetic* evaluation. Indeed, Horton (1965a, 12) remarks that masks are often held to be ugly and are feared by pregnant women lest their children be affected by them and appear as lacking in beauty as the carvings. Further, Kalabari carvings are often kept in dimly lit shrines where they are difficult to distinguish clearly (fig. 2). Access to such works is also limited owing to fears of mutual pollution. It is believed that contact with an unclean person may anger the spirit; contact with the spirit may be dangerous to one who has not been properly prepared. The separation of images from excessive contact is a mark of, and a precondition for, their power. Traditionally, therefore, important shrines have been closed to those not of pure Kalabari birth,[25] and women can only approach them through intermediaries. (As a channel of communication of spiritual power, such "official" shrines are in stark opposition to the possession cults of marginal Kalabari women (Horton 1969).[26])

It might be thought that masks used in public performances would be of great

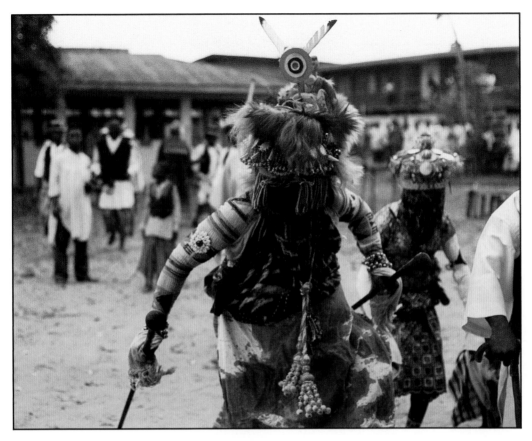

Fig. 3. Krokonje masquerade, Buguma, 1987.

visual prominence. Frequently, however, they are hidden in a mass of minor decoration and are lacking in visual force (fig. 3), or their faces point toward the sky so as to be virtually invisible to spectators.

Given this attitude to wooden images, it would clearly be inappropriate to seek to place Kalabari carving in the Western rubric of "art." Aesthetic interest is an important element of masquerade performances but is centered on the correct execution of steps by the dancer (Horton 1963). It is true that secondary decoration—called "fancy" in Kalabari pidgin—may be attached to carved masks. Fancy includes elements such as paint, feather dusters, mirrors, and Christmas decorations. At the end of a masquerade performance, this decoration will be stripped from the masks and carefully stored for reuse. The carved mask is hung up in the dark under the roof beams of the ancestral shrine and is now held to be particularly unattractive and devoid of power, since the spirit is no longer in it.

The decoration of the mask marks its fitness for participation in a public performance. The interest brought to bear on it, however, seems not to be primarily aesthetic but social. The primary requirement is that the mask, as well as the performers themselves, be appropriately dressed for a public event. The powerful aesthetic brought to bear on a masquerade is thus an aesthetic not of art objects but of performance that is focused on the transient medium of dance. An excessive concern with the aesthetic merits of semianthropomorphic images such as wooden masks *is* part of Western canons of taste. It has nothing to do with the Kalabari themselves and the way they view these objects.

Kalabari discussions of carving tend to stress the correctness of the representation. Discussions of replacement pieces are phrased not in terms of, Is it beautiful? or even, Is it a good copy? but ultimately in terms of, Will it work? Creativity, then, has only a small part to play in Kalabari sculpture. Like many other African traditions, that of the Kalabari puts little stock in mere innovation.[27] Thus, Horton (1965a, 17) remarks concerning the commissioning of sculpture, "The commonest form of order is one for the replacement of a decayed cult object." Spirits may become annoyed at the neglect of cult objects and images. These must be a fit location for the spirit. Carvings for the location of spirits must incorporate the motifs distinctive of each spirit and must sufficiently resemble the piece they replace to be recognizable. Horton (1965a, 23) uses the analogy of handwriting:

> So long as the minimum test of legibility (i.e. recognisability of signs) is passed, one piece of handwriting is as good as another, and there is no point in making a critical comparison between the two. Calligraphic judgements are made in Western culture, but they are regarded as rather unusual and precious. In the same way, Kalabari people regarded my collector's enthusiasm over their sculpture as something decidedly odd.

When treating the place of the ancestral screens, we shall have to ask about Kalabari notions of innovation. For the moment, let us note:

> When the commission [of a new piece] involves carving an object for a new cult, however, the carver expects guidance from the spirits; and it is said that he will not go ahead without such guidance. Thus when an ancestral screen has to be made for a recently deceased chief in the New Calabar city-state, the carver will wait to be shown what he should do by the spirits of the dead who will visit him in dreams or in waking visions. But although they are regarded as crucial for the carver's work, such visitations from the spirits are seldom the stimulus for any radical invention. (Horton 1965a, 18)

Fig. 4. Modern Oki masquerade headdresses, Buguma, 1987.

The Ancestral Screens

The ancestral screens are to be considered in the context of a tradition where carvings are held to provide points of contact for otherwise free-moving spiritual entities. As far as ancestral sculptures are concerned, they are substitutes for the decayed body of the deceased, notably his forehead wherein the *teme* of the dead man resided. They are also a channel of communication by which *teme* may pass to the living.[28] Kalabari speak of their danger and power rather than their beauty.

An ancestral screen was made in the image of a particular man, but not just any man might be represented. Screens only depicted house heads or those of other social prominence. An ancestor is already a member of a cultural category,[29] a man who has gained economic success, sired many children, imposed his will on the world around him and, usually, acquitted himself on the testing ground of the Ekine masquerade society. In other words, he corresponds to the Kalabari notion of one who has led a full and desirable life, excelled in every important domain, and become worthy of serving as a model to others. Also, he has not died a bad death.[30]

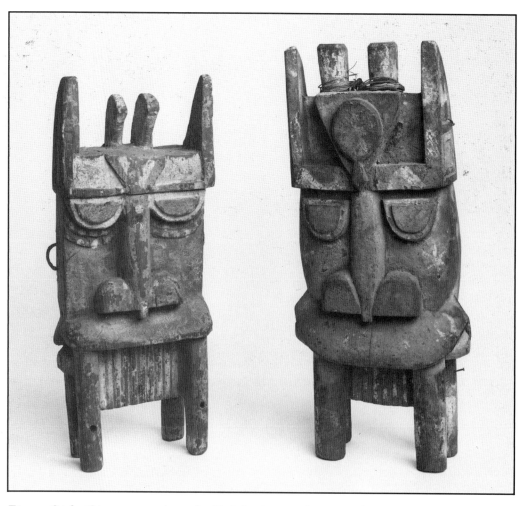

Fig. 5. Otobo (hippopotamus) masks, Kalabari group, Ijaw peoples, Nigeria. British Museum, donated by P. A. Talbot, Ethno: 1950.Af45.216–17.

But if they embody a very Kalabari set of ideas, it nevertheless remains the case that the form of construction of the screens sets them somewhat apart from the rest of Kalabari woodcarvings, which are typically carved from a single piece of wood. Those showing joining—for example, the Oki masquerade headdresses favored by young men—are declared to be recent borrowings from non-Kalabari peoples (fig. 4). Kalabari carvings tend toward formalization of features and a geometric quality, as in the well-known Otobo (hippopotamus) masks (fig. 5). Although the form of the faces of *duein fubara* recalls that of Kalabari masquerade headpieces (for example, those illustrated in Horton 1965a, pls. 45, 58), such works are unusual in that they are composite construc-

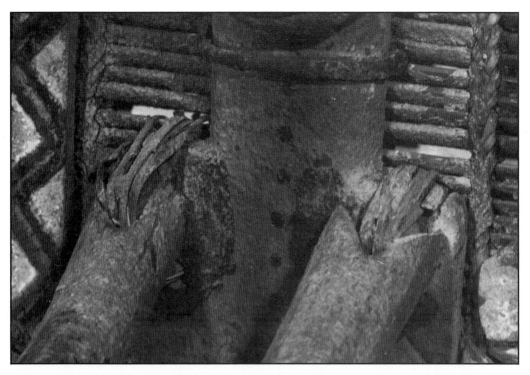

Fig. 6. Detail of catalogue number 1 showing the attachment of the arms to the torso.

tions. The many pieces of wood that constitute them are jointed, nailed, tied with raffia, stapled, and pegged. Typically, they consist of three main wooden figures that are carved in low relief and assembled from separate pieces of wood. The limbs of a figure are tied to the torso (fig. 6).[31] Kalabari sculpture rarely shows figures arranged in meaningful groupings such as this. Normally, individual figures are carved and placed in shrines in an ad hoc fashion. The frame of a screen, however, defines a self-contained space within which meaningful relationships are depicted. The whole is mounted on a backing of fiber slats (fig. 7), produced by the same basketwork techniques used to make fish traps. The figures are attached by raffia loops at strategic points—for example, around the neck—and these may be tightened by hammering in wooden pegs at the back of the screen. Solidity is lent by vertical bars of wood or bamboo, the weight being taken at the bottom by a baseplate. The feet of the figures are pegged and tied into this. Cloths are wrapped around the legs of the figures. The figures hold various objects in their hands, such as spears, swords, and human heads. The entire screen is surrounded by a wooden or bamboo frame; sometimes the backing is sandwiched between two frames that are tied together. Small heads are inserted on

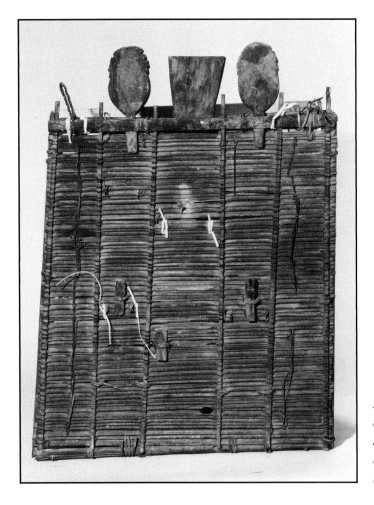

Fig. 7. Back view of catalogue number 4 showing the slat construction of the screen.

the top of the frame. The headdress of the central figure extends beyond the confines of the frame.

In the screens, the approach to the individuation of the image is striking. Although each screen is associated with a particular individual, little attempt is made to reproduce his physical traits. Thus, all the faces on a single screen are virtually identical. Individuation is achieved by the frequent expedient of marking the initials of the trading house on the frame and depicting the Ekine masquerade costume with which the deceased was particularly associated during his life. Association could be either because of innovation—the deceased was the first to acquire the masquerade— or because of the recognized excellence of the person's performance in a certain role. The relationship between houses and masquerades is complex.

First, it should be noted that the masquerade is an integral part of Kalabari life. A frequent form of play among even small children is imitating masqueraders and drummers. Young men often set up masquerade groups of varying degrees of informality. These only become a matter of concern if they too closely resemble the "official" masquerades of the Ekine society. Masks are typically connected with particular water spirits that perform at specific times in the Kalabari ritual cycle.

Within Ekine, in theory if not always in fact, separate house interests must give way to those of the society. Only some masquerades are owned by particular houses. They may have been given to ancestors in encounters with water spirits, bought, or acquired through links of kinship. Each masquerade involves several masks (often seven). Ideally, these should all be performed by members of the house that owns them. Should no house member be willing or able to undertake a particular role, however, any suitable Ekine performer may be called upon. This in no way weakens a house's claim to ownership of the mask. Informants were adamant that such a performer would have no right to use the headpiece on his own screen. Any attempt to do so would be met with force. In theory, rights through excellence of performance can only be gained in masquerades that are not assigned to any particular house. It remains the case that rights to an individual mask *may* be claimed by a man and his heirs by his outstanding performance in a masquerade. Since each masquerade involves several masks, one house may own only part of it, the rest being variously apportioned to other houses. Attempts to untangle rights to masks lead to controversy and dispute.

Other masquerades are in the public domain; they are not owned by particular houses but by "clubs" within Ekine (Horton 1960b, 101). Such a masquerade is Alagba (see, for example, cat. nos. 7, 8). It is primarily for entertainment. The headdress is made of wickerwork, feather dusters, and, nowadays, Christmas tree ornaments. Unlike a headdress in the violent and sometimes dangerous "strong" masquerades, it has no carved wooden core. Besides its entertainment aspect, the masquerade also involves pointing to shrines whose names are called out by the drummer during the performance. One's ability to do this can be used as a test for full Ekine membership. The Alagba headdress is found on a large number of *duein fubara*. It seems that any competent Ekine member who could not claim a particular masquerade as his own could use the Alagba headdress on his screen as an indication that he had progressed from the junior to the senior grade by passing the "pointing" test. It might be compared, as indeed it was by one informant, to the graduation photographs beloved of modern Nigerian parents. The character of the mask is that of a wealthy and dignified house head, which may explain its appeal in ancestral sculpture of this sort. Unfortunately, nowadays it is impossible to identify particular Alagba screens that have become separated from their houses. They are insufficiently distinctive. [32]

Fig. 8. Horsfall meetinghouse, Buguma, 1987. Undecorated masquerade headdresses hang from the roof beams.

The whole question of the identifiability of the masquerader shows a tension between Ekine solidarity and house interests, which has frequently surfaced in Kalabari. Horton (1960b, 101) points out that there is an insistence within the dance society that the masquerade itself must have absolute priority and that those Kalabari prominent in Ekine are seldom the domineering, aggressive politicians who are important in other areas of Kalabari culture. In theory, the masquerader should be anonymous.[33] His face is covered and great care is taken not to use his name or let his veil slip. At the same time, he is the public face of his house, and his performance is marked by house supporters. All Ekine members, of course, know the masquerader's identity, but the depiction in a *duein fubara* of a house head with his face revealed and wearing a masquerade headpiece is a local triumph of house values over those of the Ekine group; indeed, it is something of an explicit affront to them. "The result is the curious paradox of the masquerade headpiece, which for *Ekine* is a means of effacing individual identity, but whose miniature replica on a memorial figure actually symbolizes such identity" (Horton 1960b, 109).

It is perhaps significant that the invocation of ancestors is forbidden within the

Ekine house and that on death every Ekine member is expelled from the dance society. As a final act in their relationship with the deceased, dance society members perform his personal masquerade at his funeral (Horton 1960b, 108). According to its own official ideology, therefore, there are no ancestors within Ekine itself. The dividing line between masqueraders and ancestors is held, as is that between the values of the Ekine society and those of the house.

The Ancestral Screen in the Life of the House

The *duein fubara* of a particular trading house is kept in a special side room (*ikpu*) of its principal meetinghouse (fig. 8).[34] (Sometimes a successful house has more than one *duein fubara*.) Entry to this room is carefully controlled. A general rule is that women cannot enter, although the screens are normally visible to them from the main part of the hall. This is not to say that women do not make offerings to the ancestors. Often, they may do so to give thanks for easy labor pains or the safe birth of a child. They must, however, use an intermediary because they may not approach the screens.[35] Other regulations vary from house to house since some screens are considered much more powerful and dangerous than others. Another general rule is that visitors must remove their shoes before approaching the screens. This practice is explained in terms of avoiding possible danger: one must show proper respect to avoid angering the spirit. It is striking that no restrictions are placed on touching the *duein fubara* even when the ancestor has been summoned and is held to be present. In most houses, however, those approaching the screens must first cleanse themselves with the leaf of an *odumdum* tree.

Talbot (1926, 310) remarks that one of the strictest duties of a house head was to make offerings every eight days on the mud pillars in front of the screens. At this time, the ancestors could be consulted and asked for aid by house members. The screens represented the spiritual capital of the house. If house members were bought or switched affiliation, the screens of the house went with them.[36]

Modern Kalabari have somewhat adjusted their offerings to fit contemporary conditions. Offerings of gin,[37] roosters, *agabara* fish, goats, and plantains ("male offerings") may still be required at ancestral festivals,[38] but many house heads are now Christian and feel unable to make offerings before the screens. They hand over this duty to a non-Christian member. The current head of Horsfall house, for example, holds a bottle of gin up to the screen of the founder, Horsfall Omekwe, and recites verses from Exodus 26 or 29, passages that deal with altars and the making of offerings. He then hands the bottle to a non-Christian, who pours gin on the ground, pillars, and screens while invoking good and bad spirits—including the dead without houses[39]— and finally calling the house founder. Another glass is used to offer from the same bottle

to the living. The house head drinks from this with every sign of discomfort. In recent times, the willingness of house heads to offer to the shrines has become a political issue used to reinforce or weaken claims to succession.

Oelmann (1979, 42) is puzzled by the ostentatiously public installation of a *duein fubara*, since most important Kalabari carvings are carefully preserved from public gaze and contact. This unusual behavior becomes clearer if we consider the making and inauguration of a screen and the political importance of making offerings to it.

According to Leonard (1906, 162–65), the screen of a Kalabari notable was made in the year following his death. According to Talbot (1932, 237–38; 1926, 309–10), however, it was made when the "Peri play" had been arranged,[40] which might be many years after the death of the individual concerned. All screens were made by the Pokia family of Ifoko (Fouche, Fuchea).[41] They were transported under cover of darkness to the compound of "one of the other chiefs, usually the greatest personal friend of the late departed" (Leonard 1906, 164). There was a ritual battle in which the relatives of the deceased were finally triumphant and carried off the screen to be installed with suitable sacrifices in the meetinghouse.[42]

There are a number of differences between the accounts of Leonard and Talbot, but certain themes are clear. First, there is a distinction drawn between house members and outsiders. "The family sing that they have brought their father back in safety from those who had taken him prisoner" (Talbot 1932, 238). Next, we have a distinction between freeborn Kalabari and slaves. Leonard (1906, 164) remarks, "This is done in a formal manner, only the sons of the late departed or the elected freeborns of the house being permitted to touch or handle it [the screen]." Talbot (1932, 237) writes, "Only 'lawful' sons of the deceased may be present at such a time." The notion is a difficult one.

Jones (1963, 57–62) points out that there were two parallel systems of ranking in operation in the Niger Delta in the nineteenth century, one based on birth and the other on wealth. European observers persistently tried to conflate them, confused by the Kalabari use of the idiom of kinship and the mechanism of adoption to force social realities into a descent model. Given the fluid and competitive conditions of life in the trading polities, it is clear that making offerings to the screen of a predecessor established legitimacy. It was a declaration of achieved succession and put an end to rival claims. It is therefore not surprising that this was a public act. It was only the transfer and first sacrifice that were major public events. Thereafter, the screen remained in the semidarkness of the chiefs' meetinghouse.[43] Commenting on the question of the visibility of the screens, one informant remarked that the screens were there not to *be seen* but to *see*.

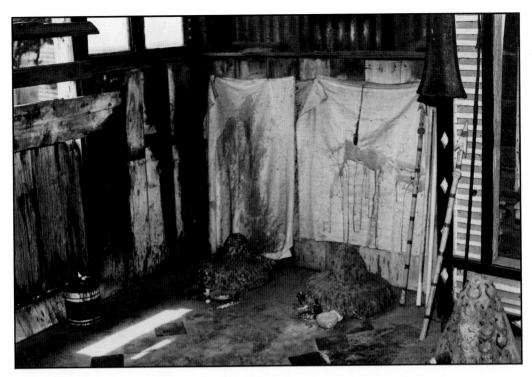

Fig. 9. Ancestral shrine before the commissioning of an ancestral screen, 1987. A simple cotton cloth substitutes for the screen.

Western researchers such as Oelmann have tended to show a predictable bias toward the anthropomorphic, more readily "artistic" elements of Kalabari shrines. Talbot (1926, 310) makes it clear that the *duein fubara* were far from being the most significant part of the assemblage. The mud pillars erected in front of a screen were the most important part of the shrine. "These phallic pillars are the essential part of the symbol and are to be seen in the households of all men of importance." He says that they too were called *duein fubara*. In noting that the pillars were also called *duein fubara*, Talbot was likely mistaken. Contemporary informants refer to the mud pillars as *otolo*. A typical ancestral monument is faced by three of them. Interpretations of the pillars vary. Sometimes they are explained as being one for each of the three figures of the screen, and sometimes as being for father, children, and grandchildren. Yet others explain the three pillars as being for the gods, the dead, and the living. If the screen of a man is in the same alcove as that of his father, it must be against the side wall and not beside the father's screen. Also, it only has one, not three, *otolo* (fig. 9). Before going to war, offerings would be made on the shrines and young men would be marked with dust from the *otolo*.[44]

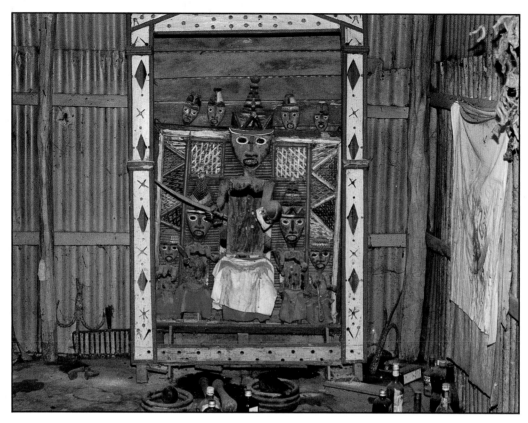

Fig. 10. Ancestral shrine of Amachree I, Buguma, 1987. The screen has undergone numerous changes since the time it was photographed in the 1920s (fig. 2).

Although Talbot seems to be correct that a sculptural screen is an optional extra, it is not the pillars that are sometimes referred to as *duein fubara* in such cases. Instead, a piece of white cloth is fixed to the wall above the pillars (fig. 9); this cloth may be called *duein fubara* in anticipation of the installation of a screen. Offerings are made on this until such time as a screen has been purchased.[45] The screen is then leaned against the cloth inside a wooden alcove (*arua*). Informants maintain that the making of a screen may be done many years after a man has died. Indeed, funds may never be adequate to allow this addition to be made. When showing me such cloth shrines for persons who died more than fifty years ago, house heads assured me that they would be augmented with *duein fubara* as soon as funds permitted.

Other elements of ancestral shrines are hats, pieces of furniture, cannon balls, bottles of drink, glasses, musical instruments, and masquerade headpieces stripped of featherwork decoration (fig. 8).[46] During the masquerade period of the ritual cycle,

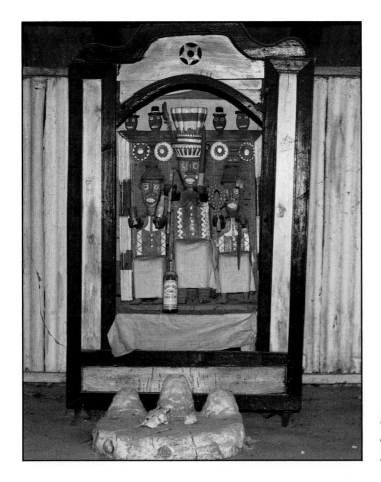

Fig. 11. Replacement for ancestral screen of Jack Rich, Buguma, 1987.

immediately before a house performs its masquerade, the headpiece is placed before the screen featuring the mask (fig. 1). Nowadays, there are drastically fewer of these items in an ancestral shrine. In former times, the shrines were a world in miniature: the world of a successful Atlantic trader.

Large twisted brass manillas, called *ovo*, are another major element of shrines. It is a privilege of the chiefs of certain houses that at their deaths women may perform a special dance wearing these manillas.[47]

During the ancestral period of the ritual cycle, special offerings are made to the screens, which are scrubbed, painted, and, where necessary, repaired.[48] The most common change is in the cloths that the main figures wear. When an important screen falls into disrepair, it may even be completely replaced.

Such is the case with the screen for Jack Rich (Benibo) (fig. 11). Tradition assigns his death to 1850 and the installation of his *duein fubara* to 1858. Recently, according to

an informant, it was damaged "by a lunatic." In 1985, after much discussion, it was decided to replace the screen. A carver was finally found who was prepared to take the terrible risk of creating the new screen. It was explained to me that the new screen was costly because the carver demanded a huge price for putting his life in danger. The danger stemmed from the many years of offerings made on the original screen,[49] which was used as a model. The original backing was reused, but the figures were completely replaced. The remains of the old ones were buried in a coffin, "like a man," behind the shelter where the new screen is kept. The screen had to be transported at night; it was reported that a huge wave sent by a water spirit nearly upset the canoe. Constant offerings had to be made to the water spirits to allow the passage of the screen.[50] This is said to be the first *duein fubara* made in recent years, and the consequences of such a renewal are being closely watched by other houses. Many of the screens are now in such a state of disrepair that they are in danger of disappearing forever. A period of restoration and renewal seems imminent.

Origin and Dating of the Ancestral Screens

History for the Kalabari is intensely political. The researcher soon learns that everything has its official version, which is entrusted to recognized leaders.[51] Ordinary Kalabari deviate from such received orthodoxies at their peril.

One such official history concerns the Amachree dynasty. The dominant Buguma tradition sees Amachree I as the beginning of everything. There were no kings before him, and life at that time is described as a state of unredeemed animal savagery. It is hard to pin down Amachree's dates according to a Western chronology. He probably lived between the second half of the eighteenth and the early nineteenth centuries (Jones 1963, 134–38). The Kalabari place the beginning of his reign far back in time. Informants therefore seriously maintained that Amachree lived for several hundred years.[52] It is inevitable that he should be described as the first Kalabari to have a *duein fubara*.[53]

Oelmann (1979, 42) argues that since the screens are associated with trading houses, the development of trading houses explains the development of the *duein fubara*. Moreover, it is the expansion of royal power that is critical. "The development of a monarchic element in New Calabar required the evolution of a monarchic cult symbol" (Oelmann 1979, 42). Indeed, but monarchic elements and trading houses appear centuries earlier than the screens (Alagoa 1972, 138), and there is nothing particularly "monarchic" about the screens.

Although claims that Amachree founded kingship and the house system seem exaggerated, he was clearly a great leader and organizer who came at a time of crisis. More important for strengthening the claim that he originated the form of the screens is

that he is credited with restoring the shrines of the gods after a great fire. Alagoa (1972, 207) repeats a tradition that Amachree was a slave. This is probably overstating things, but he does seem to have been the first king of foreign origin. Historically, it does make sense to think of Amachree as a possible innovator in memorial carvings.

The problem of establishing correlations between artistic and social forms lies precisely in that such imputed links are tautological and nonfalsifiable. Thus, material objects whose ownership is restricted may be held to *reflect* a differential distribution of power and privilege, *create* such a differentiation in other areas of culture, or *act as a substitute for* such a differentiation. Although it has always been a matter of faith for researchers in the anthropology of art that a relationship exists between art and society, it has always proved impossible to predict what that relationship is. The only predictions that "work" turn out on closer examination to be mere tautologies. We should therefore not be too hasty in seeking a sociological source of the *duein fubara* in the revolutionary reign of Amachree I. Rather, we should look at any internal or external evidence that could help with dating.

First, the internal evidence. As will be seen from the discussion of the individual screens in the catalogue section of this book, European hats feature prominently in the *duein fubara*. The giving of hats to local rulers was a well-established custom in the Niger Delta.[54] They often made up a part of the payment that allowed a trader to begin business. It seems as if the area was used as a dumping ground for outmoded headgear.[55] Because we know nothing of how soon local manufacturers began to copy European hats, hats appearing on an ancestral screen can only be used to give a date after which the screen could have been made. The top hat in catalogue number 4, for example, seems to be a style that dates from the late 1820s in Europe.[56] This screen, therefore, must have been made after that time—possibly very much later. The hats worn by the small figures on the top of catalogue number 8, on the other hand, date from 1870 to 1890. There seems to be no reason, then, to assign this screen to an early period.[57] In fact, none of the screens I was able to see in Kalabari features other than nineteenth-century European hats.

What then, of the external evidence, such as the accounts of visitors to the Niger Delta? Are there descriptions of ancestral screens to be found here? Unfortunately, there are not. The early chroniclers—Pereira, Dapper, and Barbot—have little to offer. In the eighteenth century, Barbot has a description that *might* refer to ancestral shrines:

> Every house is full of idols, as well as the streets of the town. They call them *Jou-Jou*, being in the nature of tutelar gods. Many of them are dried heads of beasts, others made by the *Blacks* of clay and painted, which they worship and make their offerings to. Before the king goes aboard a ship newly come in, he repairs to his

idol house, with drums beating and trumpets sounding, all his attendants bare-headed. There he makes abundance of bows to those puppets, begging of them to make his voyage prosperous. . . . Every time, their small fleet of canoes goes up for slaves, and when they return, they blow their horns or trumpets for joy; and the king never fails, at both those times, to pay his devotions to his idols, for their good success, and a short voyage. (Jones 1963, 41)

It is not until the nineteenth century that descriptions of shrines become more specific. De Cardi (1899, 506) offers a description of a Kalabari "Ju-Ju house" of the 1860s:

The Ju-Ju house had among its possessions several ill-shaped wooden idols, and scattered about the affair that represented an altar were various small idols looking very much like children's dolls; also several large elephants' tusks, and two or three very well carved ones, with the usual procession of coated and naked figures winding around them.

Unfortunately, this is not an ancestral shrine but recognizably that of the national deity, Owamekaso, described as it appeared at Buguma after the dissolution of New Calabar (Talbot 1932, 77). A further description confirms this.

Their Ju-Ju house in the original town was a much larger and more pretentious edifice than that of Bonny, garnished with human and goats' skulls in a somewhat similar manner, unlike the Bonny Ju-Ju house in the fact that it was roofed over, the eaves of which were brought down almost to the ground, thus excluding the light and prying eyes at the same time; at either side of the main entrance, extending some few feet from the eaves, was a miscellaneous collection of iron three-legged pots,[58] various plates, bowls and dishes of Staffordshire make, all of which had some flower pattern on them, hence were Ju-Ju and not available for use or trade—the old-fashioned lustre jug, being also Ju-Ju was only to be seen in the Ju-Ju house, though a great favourite in Bonny or Brass as a trade article—at this time all printed goods or cloth with a flower or leaf pattern on them were Ju-Ju. Any goods of these kinds falling into the hands of a true believer had to be presented to the Ju-Ju house.

As [European] traders took good care not to import any such goods, people often wondered where all these things came from. Had they arrived shortly after a vessel bound to some other part had the misfortune to be wrecked off New Calabar, they would have solved the problem at once, for anything picked up from a wreck which is Ju-Ju has to be carried off at once to the Ju-Ju house.

Unsatisfactory as these passages are for giving us a picture of what would be contained in an ancestral shrine at this time, they nevertheless *do* shed light on a major process structuring the development of shrines in general.

Except for those visiting the shrine of Owamekaso, figured cloth may nowadays be worn in Kalabari.[59] In the past, however, the Kalabari prohibition of figurative designs was much greater, as attested by Waddell (1863, 420):

> At New Calabar, as at Bonny and some other places on the coast, the people all wore charms about their necks, to preserve them from sudden calamities. But though of the same stock as the Bonny people, speaking the same language, some of their customs are different. For instance, books and pictures are *juju*, or sacred, as also flowered or figured cloth or earthenware. Such things cannot be traded in or made common. They are lodged in the *juju* house, where I saw them arranged along the walls; with carved figures and such like.

Smith (1851, 63) makes the same point:

> In New Calabar the shark is Ju-ju, and cloth or any other article having on it the figure of any animal or thing is Ju-ju . . . it is not worn or used in any way.

More generally, Africans all along the coast were having to deal with a flood of new Western goods and images. Many Western visitors to the Niger Delta area commented on the heaping up of useless imported exotica (Waddell 1863; Crow 1970, 273; Hutchinson 1858, 124–25).

> A sketch of one of the trading gentlemen's houses will suffice for the whole. . . . Looking to the large room, the first idea of wonder that came into my mind was, how the person who fitted it up managed to get out of it, or if he did get out without breaking anything. There did not seem to me to be space for a fly to turn or stand within its precincts. China and glass jugs, all kinds of delf and crockery-ware, mirrors in profusion and of every size, blue decanters, chandeliers and pictures, glass globes and China vases, with an uncountable quantity of indescribable jimcrackry, seemed heaped up to repletion. (Hutchinson 1858, 124–25)

It is a picture of possession run wild, wealth beyond the control of its owner. But efforts *were* being made to impose a system on Western goods. It is too late now to know what systems structured the whole range of material objects before the impact of the West. In some of the large polities, there were efforts to organize sumptuary rules: certain goods were limited to certain social groups.[60]

New Calabar seems to have made unusual efforts to master conceptually and

Fig. 12. Young Ekine society member, Buguma, 1987.

subdue pragmatically the flood of imports. For example, rules were introduced to limit imported items such as cloths, canes, and hats to chiefs.

> When seen in public, the well-dressed Kalabari man is not without a walking stick or cane. This is definitely Western in origin. Canes were a sign of class in 19th century England. Umbrellas eventually came into fashion. They are also used by the Kalabari and function as a walking stick. I think that the Kalabari picked up on the importance of canes from the English. At the turn of the 19th century, canes showed status. (Case 1987)

The Kalabari introduced regulations limiting the use of canes to special classes of people and events. Such rules protected important markers of status from wealthy parvenu who could otherwise simply buy them. The rules were a source of great bitterness among the young and ambitious. In return for support from the young men

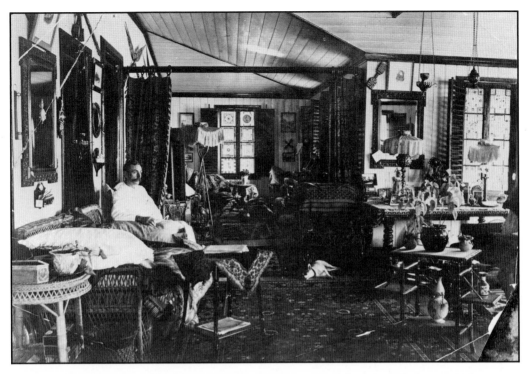

Fig. 13. A trader named Mr. Powis, New Calabar, 1896. He was killed on a diplomatic expedition to the Benin Kingdom in 1897.

during the Kalabari civil war, chiefs in some towns were forced to make concessions on the rules concerning canes and hats. Even today, young Ekine members flaunt the right to use them with pride (fig. 12).

The inrush of new sorts of images created the greatest problems for a rigid traditional classification of material objects. Figure 13 shows a Western trader's house in the Niger Delta in 1896. Note the sheer wealth of images: a doll, paintings, photographs, newspapers, cigar labels. It is a truth familiar to the anthropologist—but hard to conceive for the contemporary Westerner—that people have to learn to interpret two-dimensional images. By the late nineteenth century, African forms of perception were still radically different from those of the West. Most of the reports predate any pretension to accurate ethnography and are largely anecdotal (for example, de Cardi 1899, 60). We can see, however, a not surprising tendency to interpret the unknown through the known. Thus, there are anecdotes about a pack of cards being interpreted as a divining instrument (Cole 1862, 150) and about pictures of Queen Victoria and Prince Albert being regarded as "idols" (*arrisi*) of indeterminate sex by the Yoruba king of Aboh (Crowther and Schoen 1842, 58–59).

The presence of European images in religious contexts is also well attested. Smith (1851, 67) writes of Old Calabar, located to the east of New Calabar:

> Every gentleman has his JuJu room, every great gentleman has his priest, and the poorest householder erects a little altar, and ornaments it with such articles of vertu as he can command. I have often seen a sheet of *Punch's Picture Gallery* or a sketch from the *Illustrated London Newspaper* occupy a conspicuous place.

Books could puzzle local people, especially if illustrated. Fawckner (1837, 21) describes an incident after being shipwrecked on the west coast of Africa:

> During our stay, we were much amused with the superstitious fears of the old chief, who at different times returned several of our books, as he feared to open them, conceiving they were fetish or charms.
>
> On one occasion, he brought a large folio bible belonging to the supercargotrader, which had given him great uneasiness and disquiet of mind; he therefore thought it advisable at once to get rid of it; and, dressed in my jacket, with one of my nightcaps under his hat, this curious old fellow came to us with the great volume under his arm; several of the natives accompanied him, who had all come to the conclusion that it was white man's fetish. We were willing to take advantage of their fear; and holding the sacred volume in one hand, I pointed with the other to the sky, telling them, at the same time, it was God's book. They seemed much impressed if we might judge from their countenances, as they withdrew at a respectful distance from it, but their awe soon subsided into amazement and surprise, when we opened the book and began shewing them the pictures it contained. They then looked over our shoulders and seemed highly pleased, as we turned over the leaves, not daring to touch it all the time.

The presence of a special book in the Owamekaso shrine of the Kalabari is hinted at by Alagoa (1972, 141):

> After Oruyingi [mother of the gods] had given birth to all the gods of all *ibe* in the Delta, she asked them to make requests for the benefit of their people. Owamekaso asked for a book that would attract European ships to Elem Kalabari [New Calabar]. After they left the presence of Oruyingi, Ikuba became jealous and tried to seize the book. In the ensuing struggle, Ikuba was able to make off with the larger fragment of the book and so got the bigger ships calling at the port of Bonny, only smaller ships being able to go upstream to Elem Kalabari.

What seems to have been unusual at New Calabar is simply that, for a short period at least, *all* images were allocated to the "JuJu house." The point is that just as

Westerners were interpreting the acts of locals with the catchall categories of "juju" and "fetish," the Africans were observing the Europeans and trying to assign their products to the appropriate deities. Unfortunately, the European use of these terms does not allow us to penetrate very far below their assumption of the sameness of the different shrines. It is clear that certain European influences have affected Owamekaso, the Kalabari national deity. At her temple in Buguma, bells, incense, and white robes are used. Her name has undergone reinterpretation to become Awomekaso, "the spirit who cherishes children," and she is now identified as a shipwrecked Portuguese nun of the sixteenth century. In her shrine is a cloth *arua* such as would elsewhere contain an image. But here it is empty.

> There used to be two carvings of a human image, but these no longer exist in the shrine. Apart from these there are no human representations in the shrine to suggest the figure of Owomekaso [*sic*] and what she looked like; not even paintings exist. But the lost images had European features like a pointed nose and thin lips, as I discovered from enquiry.[61] (Tasie 1977, 23)

It is evident, then, that the Owamekaso cult has been influenced by Western goods and images. In the absence of further information, it is difficult to know what may have been happening in the *ancestral* shrines. Talbot (1932, 80, 140) suggests that the precursor of the screens were carved stools (*osisi duein*), but modern Kalabari deny this. In the matter of cult objects, as in the matter of kingship, it is not permitted to speculate beyond Amachree I.

Heavy Western influence can clearly be seen in the construction and design of the screens. A frame is used to create a discrete space within which meaningful relations can be portrayed. Many of the motifs on the frames seem to derive from Western sources, possibly even from the suits on playing cards (see, for example, cat. nos. 2, 8). There is a wealth of different types of joining: miter, mortise, abut fitting, and pegging. It seems likely, then, that we should consider the possibility not just of the use of European techniques but of a European source that inspired the screens. A clue as to how this might have come about is suggested by Horton (1970, 207):

> The almost universal rejection of missionary preaching against the spirit cults which characterised the period 1866–1890, hardly needs any explanation. The heroes, ancestors and water-spirits were beings peculiar to Kalabari, so what authority had outsiders to make pronouncements about them? True Kalabari seem always to have suspected that the Europeans had their own cults of heroes, ancestors and the like.

Thus, just as some Western images would have been accepted as appropriate to the shrine of Owamekaso, so some would have been interpreted by the Kalabari as "ancestors of the White Men" and led to the act of imaginative translation that was the invention of the *duein fubara*. Kalabari would have been actively scanning the productions of the West to find images that corresponded to their own partition of the spirit world.

I am aware that to ascribe all change in Africa to external European influence is yet another pernicious cultural myth,[62] but I suggest that we should sympathetically consider this possibility for the Kalabari case. The screens, after all, appear as part of a more complex rite of burial involving European foods, clothes, weapons, and language.[63] In addition, it should not be forgotten that European ships were floating ateliers of artisanal skills: brasscasting, ivory carving, joinery, and patchwork quilting. On the west coast of Africa, such "traditional" African skills still show a high correlation with areas of Western nautical contact to the present day. The link between the screens and the people of Ifoko is also suggestive. Ifoko people provided the pilots for European vessels on the New Calabar River and so would have had access to parts of vessels not available to others. Commonly, vessels would be stationed at Ifoko for their entire stay on the river. It seems that the people of Ifoko had an eye for Western innovation. De Cardi (1899, 508) remarks concerning wigs:

> The fashion of wearing wigs, I am afraid, was unconsciously inaugurated by me, having taken with me in 1865 to New Calabar some wigs that I had used in some private theatricals in England. A chief named Tom Fouche saw them, and was enchanted with a . . . trick wig, the top of which could be raised by pulling a hidden silk cord, and eventually he became the proud possessor of my stock, and produced a great sensation the first public festival he appeared at.

The case is trivial but must have been typical. Kalabari culture itself is an assemblage drawn from many sources.[64] To say this is not to devalue Kalabari culture. The Kalabari show great ingenuity in the ways they use elements of foreign origin to construct a notion of essential Kalabari-ness. Since a high proportion of house members and even leaders were of non-Kalabari origin, the same process of "authentication" was applied to them in a ceremony where new slaves were shaved, circumcised, fed, and given a new name and new parents (Eicher and Erekosima 1982). They were thus "authenticated" just like the imported cloth that was reworked into the Kalabari textile known as *pelete bite* (drawn-thread cloth) (Eicher and Erekosima 1982), the playing cards and stainless steel cutlery that became part of masquerade headdresses, and the cannons that became seats in the temple of Owamekaso. Kalabari abounds with imported exotic items that have been absorbed and integrated as symbols of Kalabari

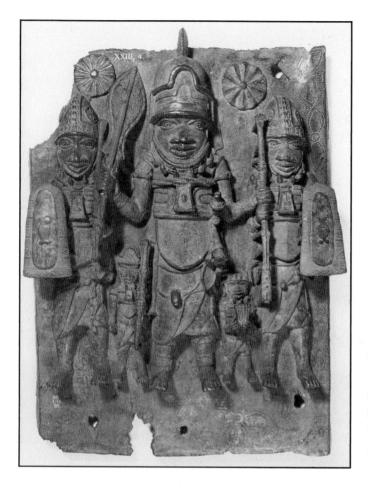

*Fig. 14. Brass plaque,
Benin Kingdom, Edo
peoples, Nigeria. The
plaque depicts a notable
and his attendants.
British Museum, Ethno:
1898.1–15.85.*

identity. Before we consider the possibility of Western inspiration for the *duein fubara*, however, there is one more myth to consider: that their origin is Benin.

In the early days of European conquest, many of the peoples of southern Nigeria saw the wisdom of associating themselves with a power regarded by the British as "civilized" as a means of improving their position in the eyes of the new colonial authority. To the British, the Benin Kingdom was considered relatively civilized as it possessed "art" (Read and Dalton 1899). According to the dominant diffusionist viewpoint of that time, attributing something to Benin influence was an intermediate stop on the way to tracing it to ancient Egypt as the source of all higher developments in Africa. Small wonder, then, that several Niger Delta peoples constructed an identity based on origin from Benin.[65] It is a more recent part of the same historical thread that sees the screens as deriving from the Benin plaques (fig. 14). These works of cast brass depict scenes of court life and are conventionally assigned to the period between 1550

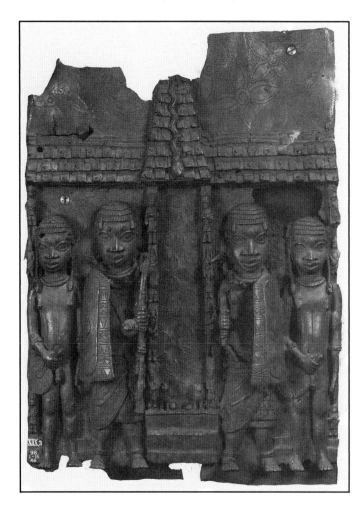

Fig. 15. Brass plaque, Benin Kingdom, Edo peoples, Nigeria. The plaque shows the royal palace decorated with other plaques. British Museum, Ethno: 1898.1–15.46.

and 1650. They are rectangular, often incorporate a central figure flanked by two others, and have the same frontal quality and use of internal space to show relations that we see in the Kalabari *duein fubara*. The similarity is largely spurious, however, for it is only in Western museums that the plaques are separated and therefore recall Western paintings and Kalabari screens. When seen in use, covering the wooden beams and pillars of the Benin royal palace, they are immediately recognizable as metal versions of the carved roof supports so well known from other West African kingdoms (fig. 15).[66]

If we consider a single European image as the source of the *duein fubara*, what would its characteristics be? It would be a framed two-dimensional image. Catalogue number 6 suggests we may be dealing with an outline engraving rather than a painting. (A book engraving is not excluded, since many eighteenth- and nineteenth-century

Fig. 16. Kalabari chiefs, probably c. 1880.

books have illustrations within a frame.) Europeans behaved differently toward different types of images from their own culture. A Kalabari interpreting such behavior might well find that the respect accorded to biblical images or official portraits fit his own notions of proper behavior before an ancestral image. Possibly, the European prototype would have three figures in an elaborate frame surmounted by a carving—for example, a frame bearing a crown—that could be interpreted as the headdress of the central character. A number of candidates emerge—for example, the common subject "Solomon in his Majesty" of biblical tradition—but there is yet another intriguing possibility.

Photography came early to the Niger Delta. By the 1870s, King Eyo Honesty of Creektown in Old Calabar to the east of the delta had a photograph album, and photography was popular among European visitors.[67] It has been noted that just as many of the conventions of European painting fed into Western photography, photography of and by Africans has been deeply affected by the poses of indigenous sculpture.[68] So, when Northcote Thomas photographed the Bini about 1910, they assumed the symmetrical poses of the plaques.

Among the Kalabari, there has been a similar development. Photographers have

Fig. 17. A framed photograph of Prince George Amachree, Buguma. He died in 1890.

noted that the Kalabari dislike informal snapshots.[69] They require to be photographed in formal frontal poses in a manner that demonstrates that they are physically complete. Thus, fingers will be spread, toes uncovered. By the time when we begin to have photographic evidence, about 1880, Kalabari chiefs assume the same poses and arrangements of retainers that are shown in the screens (fig. 16). Here, as in Benin, the formal encounter, the group photograph, and the traditional sculpture have come together.

Modern Kalabari constantly refer to photographs—"snaps" in Kalabari English—when interpreting the *duein fubara*. The screens are "the imaginable faces of our forefathers," according to one chief. "In those days we had no cameras." Kalabari explain the poses of the screens by referring to family portraits or even newspaper illustrations of Nigerian football teams. Owners of screens almost invariably place the photograph of a deceased forebear beside his screen and attempt, often vainly but with

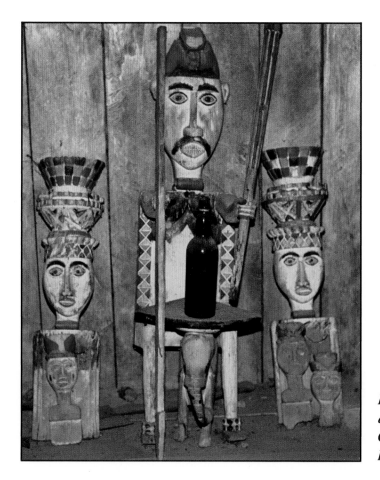

Fig. 18. Figures from the ancestral screen of Prince George Amachree, Buguma, 1987.

great determination, to "see" his physical traits in the carvings (figs. 17–18).[70] Photographs are too late, of course, to be considered as a source of the screens if we assign their origin to the period of Amachree I (the late eighteenth to the early nineteenth century). Screens, however, were always made retrospectively, often many years after the death of their subjects. Yet, they are always dated within the overarching myth that everything began with Amachree I.

There is a further link between screens and photographs. Although early photographs of Kalabari exist, their number is small. Informants explain that their grandparents were unwilling to be photographed lest their *teme*, or spirit, be caught, causing their death. There was a clear link made between representational image and death, the causal intermediate concept being "spirit." The Bonny photographer J. A. Green is said to have responded to this by devising techniques for photographing people without their knowledge and consent. Figure 17, said to be such a photograph, was

Fig. 19. Modern Ngbula masquerade, Buguma, 1987.

apparently taken while the subject was sitting in a boat.

So we are left with a mystery. Did the conventions of the group photograph derive from the *duein fubara* screens or vice versa? Given the retrospective nature of screen production and the absence of internal evidence calling for other than a late-nineteenth-century dating, both are possible. It is an interesting thought that contact with other ways of seeing and the invention of the camera led Africans toward more naturalistic sculpture as firmly as it encouraged Western artists in the opposite direction. It is the familiar situation of two cultures in contact but looking steadfastly past each other.

Fig. 20. Discarded Bekinarusibi mask, Buguma, 1987.

Catalogue Raisonné of Kalabari
Ancestral Screens in Museum Collections

Although each *duein fubara* is unique, the screens share a number of common features that influence the ways in which they are interpreted by the Kalabari. The subject of the screen is always the central figure. Flanking figures represent supporters or sons. Social perspective is normally adopted—the most important figure is the largest.[71] The rectangles commonly occurring on either side of the head of the central figure are usually interpreted as mirrors. (Mirrors are a common embellishment of masquerade headdresses. See Horton 1960b, pl. 8, for a depiction of the Gbasa masquerade headdress, which incorporates square mirrors on either side.) Some informants, however, saw them as "windows." Small heads at the tops of screens are seen as either the followers of the house or the followers of the masquerade, that is, Ekine members. The two categories, of course, would overlap. Small heads between the feet are taken to be children or vanquished enemies. The small dotted marks on the torsos of the larger figures are taken either as bones—showing them to be mortals rather than gods—or as representing the knotted tassels worn by masqueraders across their chests. Most screens have two raffia suspension loops at the two top corners. Only occasionally are these used nowadays in Kalabari to pin the screens back at an angle against the wall. As the screens have become more decayed, various informal arrangements have been used to display them. For example, the wooden figures may be nailed directly onto the back of the alcove in which they are housed.

Field photographs of the *duein fubara* are available for only a few of the screens in the British Museum collection. They appear to have been taken on the lawn of the British Consulate in Degema, where the screens were moved after being given to British administrative officer P. Amaury Talbot by some Kalabari chiefs. The photographs raise the suspicion that detachable pieces have been redistributed randomly.[72] The assignment of ritual paraphernalia, cloths, and smaller detachable

heads must therefore remain provisional in most cases. Sometimes, as with the Ngbula masquerade, particular objects must be held by the masquerader, so we can be sure that they belong with a particular screen. Otherwise their allocation is more aesthetic than ethnographic.

The paint on the screens is highly abraded or faded. (*In situ*, Kalabari screens have a decidedly garish quality to the Western eye.) In parts, traces of several successive coats of paint can be seen. Red, orange, blue (faded to black) and white paints of mineral and vegetable origin have been used regularly. It is no longer possible to tell whether any of the screens have the marking (white arms) of the warriors' Peri society, which is characterized by head-hunting and cannibalism, so we cannot know whether this feature was used for individuation of the image.

Many of the figures wear representations of coral beads around their necks, a sign of status. Many also have beards and mustaches—often scarcely visible—and a white spot in the center of the forehead. It is difficult to know how the forehead spot is best interpreted. Such a mark, of kaolin, may be acquired while offering to a spirit.[73] In attempting to identify from photographs the screens shown here, informants start from the masquerade. A complication is that, after the dissolution of New Calabar, many of the unique masquerades were copied in each of the settlements. Often, however, it is remembered which houses originally had rights to various masquerades and which individuals they were associated with. Further information may be gained from the initials of a house incorporated in a screen or, in one case (cat. no. 5), from the textile worn by one of the figures. A good deal of agreement is shown by the different settlements in such matters, though inevitably each settlement tends to emphasize its own prominence in masquerade.

Dimensions are given in inches and centimeters. Height is followed by width and depth.

This is a screen from the powerful Barboy group of houses. The affiliation is marked by the letters *BB* worked into the chevron pattern of the edges. It was further attributed to Will Barboy (also known as Odum). Talbot would therefore have acquired it in Bakana. The name *Barboy* is explicable either as deriving from "Barracoon Boy"[74] or from close links with Ifoko and the pilots who navigated vessels over the river bar (Jones 1963, 137).[75] Another explanation offered in Bakana was that Odum lurked around the river bar so that he would be first to open trade with an incoming vessel. Will Barboy made his mark on a treaty with the British in 1850 (Jones 1963, 141) and is said to have died young after a tempestuous life (Jones 1963, 207–8).

It is difficult to know whether the absence of hair—not unusual in a main figure—is to be linked with an insult suffered by Odum where his hair was shaved off by Prince Owuso, the king's son.[76] Underneath the headpiece is a band of blue-and-white resist-dyed *alu* cloth, used to cover the face of masqueraders.

Local legend has Odum fleeing to Benin. When he returned with many Bini habits, he was given the nickname Oba, or King. Bakana, a town largely peopled by his descendants, real and fictive, was named Obama (Oba's town) in his memory. It was King Amachree III who finally enticed Odum back and made peace between him and his enemies. He is said to have brought back a brass spear and slaves from Benin. After the slaves died, he would rest his feet on their skulls. Skulls and a brass spear were identified with elements in his screen.[77]

The central figure holds a spear in his left hand. The figure on the right holds a cane. The screen would seem to be by the same hand as catalogue number 3. Among many shared stylistic features, the fashion of binding the arms to the torso is particularly distinctive, the bindings being sunk in grooves (fig. 6, p. 23).

The masquerade is that of Pipiligbo. Small figures at the top wear Otobo (hippopotamus) masks. That on the left seems to incorporate a pot and so may be a special kind of Otobo mask (*diri pilama*) that performs at night and emits sparks in dramatic fashion. This is a masquerade not assigned to any particular house.

The mitered frame is unusual in that it is decorated with cowrie shells—a sign of wealth and trade as these were a local currency of the western Niger Delta. The wealth of Odum was legendary in Kalabari. Around his right wrist he wears a carved manilla—again a local currency, this time of the eastern Niger Delta[78]—and a bracelet of metal bells.

All three figures wear wrappers of imported striped cotton cloth.

Ancestral Screen (*Duein Fubara*)

Wood, split vegetable fiber, pigment, textile
40.5 × 29 × 15 in. (102.9 × 73.7 × 38.1 cm)

British Museum, donated by P. A. Talbot,
Ethno: 1950.Af45.333a

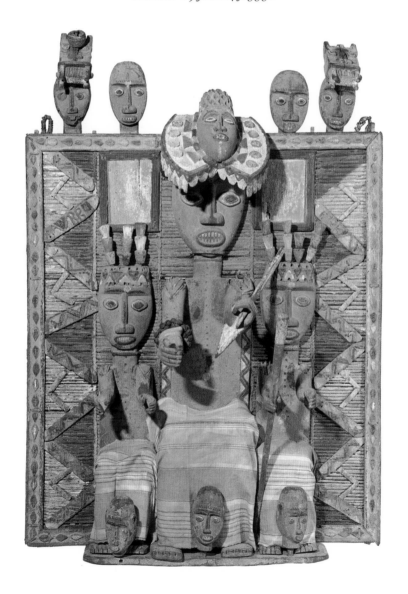

This screen depicts a man in the Ngbula, "native doctor," masquerade (fig. 1, p. 17). Ngbula is an unusual masquerade in that it may be expected through performance to rid the town of disease and malevolent influences. No other Kalabari masquerade is regarded as bringing direct benefits of this sort to its performers. (Prayers to the water spirit are normally for a successful masquerade performance.) Ngbula is a deaf local healer who is convinced that others are gossiping about him (Horton 1960a, 31). His performance, characterized by wild rushes at spectators with flailing sickles, is considered "strong" (dangerous). Figure 19 (p. 46) shows a similar mask in a recent masquerade of the Tyger Amachree house in Buguma. This mask is one of the few that face the spectators and is noted for its ugliness. The mask on the screen incorporates a metal staple at the rear from which hang locust-bean shells.

The large *M* on the frame is interpreted as referring to the Manuel (Owukori) house. The masquerade originally belonged to the Tyger Amachree house, whose founder encountered a mermaid whom he abducted while out in the creeks. This turned out to be Ngbula's wife. A confrontation ensued, which is joyfully reenacted during the masquerade. The result is that the wife is returned but rights to the masquerade are acquired by Tyger Amachree and his descendants. Manuel was allowed to perform this masquerade on grounds of kinship—he was Tyger Amachree's nephew. Manuel is known to have died before the passing of Amachree III in 1863. Bob Manuel, his son, is said to have taken the screen to Abonnema at the time of the Kalabari civil war.[79]

The central figure has a band of resist-dyed *alu* cloth, used to conceal the faces of masqueraders. Around his ankles, he wears *igbiri*, locust-bean rattles associated with the masquerade. In his hands, he carries sickles, the mark of a "strong" (dangerous) masquerade. Flanking figures wear Alagba headdresses of wood and metal. Alagba is primarily an entertainment masquerade not attached to a particular house. The figure on the left holds a cane in his left hand and the special sword of the Alagba masquerade in his right hand. The figure to the right holds a carved tusk, an emblem of rank. All the figures have painted beards and mustaches and, unusually, ears that are carved as integral parts of the head, not attached to it.

The head between the feet of the main figure is unusually formed, leading one to suspect that it might be a masquerade headpiece rather than a human head. Informants were unable to identify it.

The figures wear wrappers of striped silk.

Ancestral Screen (*Duein Fubara*)

Wood, split vegetable fiber, pigment, textile
45 × 34.5 × 15.5 in. (114.3 × 87.6 × 39.4 cm)

British Museum, donated by P. A. Talbot,
Ethno: 1950.Af45.332

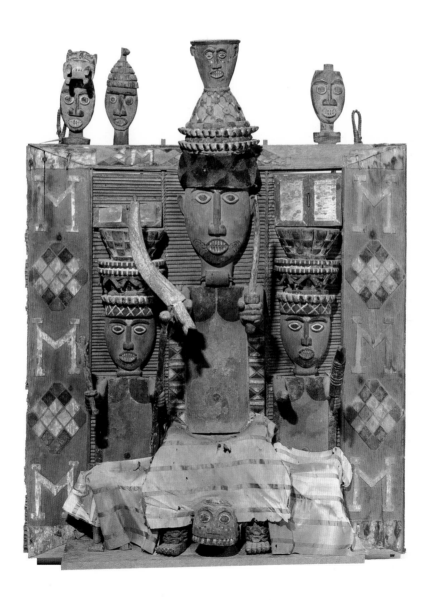

Oelmann (1979, 38) remarks about this screen, "On one of the British Museum's screens the dead person's profession of middleman trader is indicated by the representation on the headpiece of a European vessel." Far more likely, however, is that this is a fully literal representation of the headdress for the Bekinarusibi (white man's ship on head) masquerade (Talbot 1932, 310), an entertainment masquerade with a headdress in the form of a European trading vessel. Given the background of intensive European contact in which Kalabari culture was formed, it is tempting to speculate that the headpiece is fashioned not just after sailing vessels but after the models of these that formed part of the Western sailor's art. This is a matter, however, upon which no further information is forthcoming. (It should also be remembered that the fashioning of a model canoe is part of the traditional Kalabari New Year's ceremonies (Horton 1960b).) As European vessels have evolved, so has the masquerade. A headpiece in the form of a modern liner is represented in Horton 1960a, 46. Figure 20 (p. 47) shows the same Bekinarusibi headdress of Wokoma house in Buguma after it has been discarded. A recent innovation is to fill the vessel with chewing gum. The gum drops out for the benefit of children as the dancer tips back and forth. The headdress also retains links with a water spirit of the same name. Informants describe the water spirit as shimmering in the water like a jellyfish only to disappear as a man approaches.

As I have pointed out elsewhere, the form of the screen with its associated mask (bottom right) shows that Kalabari *duein fubara* have iconographic depth and draw on other levels of representation (Barley 1987, 370). Thus, they contain depictions in miniature of other Kalabari sculptures. Informants were unable to identify the mask with any degree of certainty, declaring it to be too indistinctive. It appears in this position on the screen in an unpublished field photograph by Talbot.

The screen was identified as coming from Bakana and belonging to the powerful Barboy house. This is confirmed by the initials *BB* that appear on the mitered frame. While it was impossible to assign the screen to a particular individual, obvious candidates are Awo, Odum's father, or, more likely, Otaji (Long Will), Odum's brother and heir. The central figure holds a silver-headed cane in his right hand and a curved knife in his left. The figure to the left of the screen carries a fan and a rattle. The figure on the right holds a carved tusk.

The sailing vessel incorporates European gold tassels and sails of white cloth. Underneath it and to the left are remains of a basketwork cap that would have linked the head and the base of the mask. The chevron patterns of the edges are described as "for fancy," that is, mere decoration.

3

Ancestral Screen (*Duein Fubara*)

Wood, split vegetable fiber, pigment, textile, fiber
45.5 × 29.5 × 17 in. (115.6 × 74.9 × 43.2 cm)

British Museum, donated by P. A. Talbot,
Ethno: 1950.Af45.334

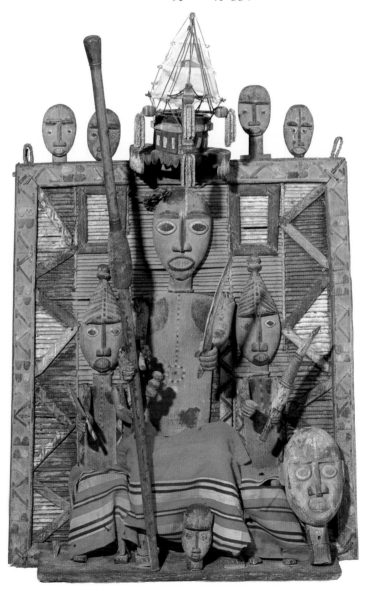

This screen is unusual in that its central figure wears a top hat, not a masquerade headdress. It has been suggested that this figure is a house head who was a Christian and therefore not a member of the Ekine society (Oelmann 1979, 38). Horton (1965a, 29) opines that such hats may be marks of status. The wearing of a top hat in contemporary Kalabari is the mark of a chief, whereas the inclusion of the feather of the vulturine fish eagle in the band indicates membership in the Ekine society. There may be various reasons why an Ekine member may not wear a particular masquerade headdress. He may, for example, have been simply unwilling to dance a major masquerade.[80] On the other hand, there have been cases where men have been warned by diviners not to attempt a masquerade and have had to limit their role to that of supporters of the society. The hat would seem to be of a date later than 1820.[81]

The figure on the right of the screen carries a curved knife or tusk in the right hand and a sling in the left. The cloths of the flanking figures have floral motifs.[82]

Ancestral Screen (*Duein Fubara*)

Wood, split vegetable fiber, pigment, textile
33 × 26 × 9.5 in. (83.8 × 66 × 24.1 cm)

British Museum, donated by P. A. Talbot,
Ethno: 1950.Af45.336

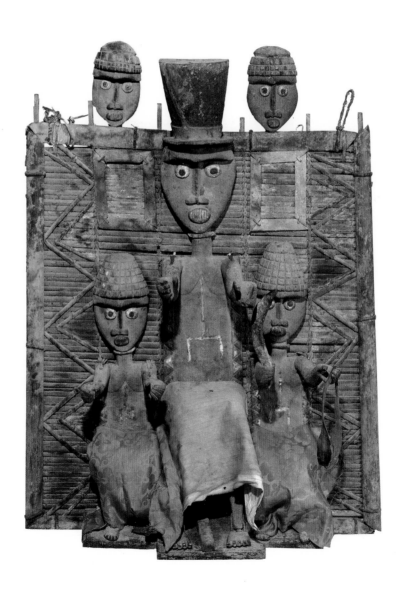

Like the central figure in catalogue number 4, the central figure in this screen does not wear a masquerade headpiece. The hat is identified as that of the *soalabo*, the high priest of the goddess Owamekaso, the national deity. The priest was also present at the Ekine masquerades. The hat was made of bamboo fronds and covered with cloth. A description of the priest is given by Tasie (1977, 28). There is no current holder of the office in Kalabari. Prime qualifications were pure Kalabari descent[83] and light skin color. It is no longer possible to accurately determine the original color of the main figure.

The priest was accorded great respect:

> The social position of the ju-ju king [the priest of Owamekaso] is before that of Amakree before his people. The ju-ju king is the head high priest, and holds the same preeminence over the monarch as Church does over State in other parts of the world. (Hutchinson 1858, 101)

The office was further linked with the wearing of a white cloth, the required dress of the officiating priest. (Since all the cloths here are fixed to the figures, they may reliably be held to be the original wrappers.) Further inquiry shows that a number of Kalabari priests wear similar dress. Horton (1969, 18) comments concerning a priest of the fierce deity Fenibaso:

> His dress includes a length of Real India[84] covered by one of White Baft, tied about the waist and belted with a strip of Ikaki;[85] a brass chain round the neck; a live chick looped about his torso on a length of fresh palm frond; a red woollen cap with two fishing-eagle feathers projecting downward over the eyes; three manillas on his right wrist, and kaolin rubbed down both his arms and across his chest. Most of these items are typical of priestly dress generally.

Informants working from photographs were not able to see anything but the white wrapper of the central figure. In fact, he wears a checked cloth underneath it. He holds a spear in the left hand and a curved knife in the right. It is not clear that these are the original accoutrements, since Owamekaso is above all a peaceful deity who abhors human bloodshed. Nowadays, she is associated with the love of children and is invoked against men who make unseemly sexual comments about women.

Since a priest of Owamekaso might be found at a number of Kalabari settlements, it proved impossible to identify the screen as belonging to any one person. A favored attribution, however, was Jack (Iju) house in Abonnema. The temple there was destroyed by Garrick Braide.

The flanking figures wear imported prints in a polka-dot pattern.

Ancestral Screen (*Duein Fubara*)

Wood, split vegetable fiber, pigment, textile
39 × 27 × 14 in. (99.1 × 68.6 × 35.6 cm)

British Museum, donated by P. A. Talbot,
Ethno: 1950.Af45.335

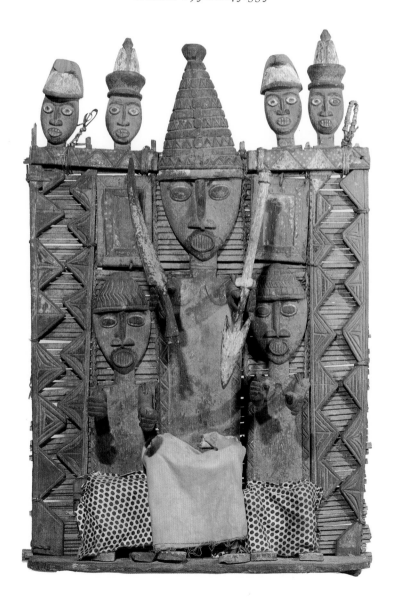

This is a unique screen. The central figure wears no recognizable Kalabari hat or masquerade headdress. The flanking figures are produced in a fashion that recalls outline drawing. Their bodies are indicated by crosshatching. It is tempting to view this object as a Kalabari effort to reproduce some of the techniques of Western prints.

The figures wear silk wrappers. Unusually, their feet are not represented, the legs being pegged directly into the baseboard.

Informants were unable to identify this screen or suggest what its origins might be.

6

Ancestral Screen (*Duein Fubara*)

Wood, split vegetable fiber, pigment, textile
29 × 24.5 × 5 in. (73.7 × 62.2 × 12.7 cm)

British Museum, donated by P. A. Talbot,
Ethno: 1950.Af45.337

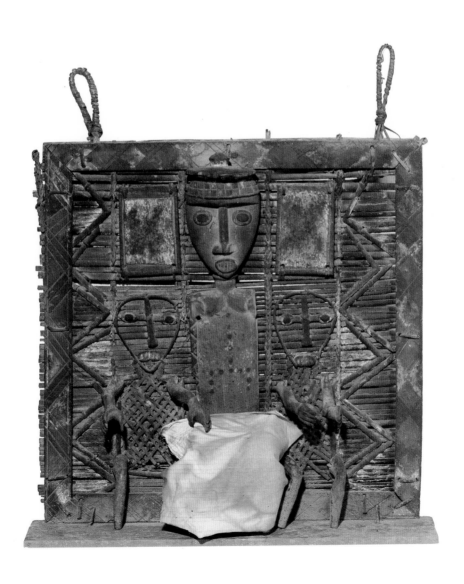

The central figure wears the Alagba masquerade headdress. He holds the Alagba knife in the left hand and a carved tusk in the right. The flanking figures wear Otobo headpieces. (The Otobo is performed after Alagba.) The figure on the right carries a single gong in the left hand and a carved tusk in the right. Gongs of this form are associated with the warriors' Peri society and are used both as musical instruments and as drinking vessels. Neither of these masquerades is specific to any house, so informants found it impossible to attribute this screen to any particular house or individual.

Two of the wrappers are of heavy satin and the third has floral motifs.

Ancestral Screen (*Duein Fubara*)

Wood, split vegetable fiber, textile
50 × 37 × 16 in. (127 × 94 × 40.6 cm)

British Museum, donated by P. A. Talbot,
Ethno: 1950.Af45.331

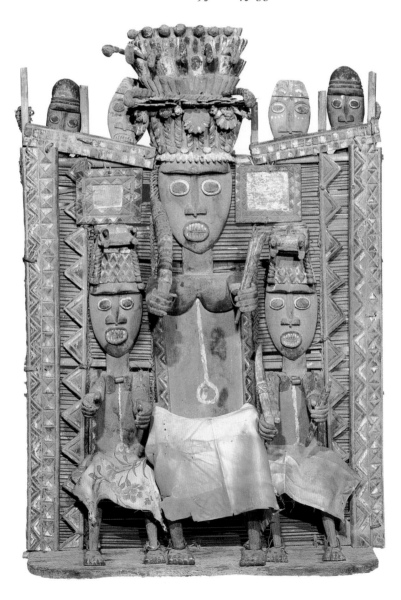

This screen, like catalogue number 7, features Alagba masquerade headdresses and therefore cannot be identified.[86] All figures wear *igbiri* anklets of locust beans. The small figure pegged into the baseboard is held to be a vanquished enemy. The central figure holds a carved tusk and a spear. The figure on the left holds a tusk in the left hand and a knife in the right hand. The figure on the right holds a carved tusk and a spear. All wear checked "India" cloth and have beards and mustaches.

Ancestral Screen (*Duein Fubara*)

Wood, split vegetable fiber, pigment, textile
52 × 42 × 17 in. (132 × 106.7 × 43.2 cm)

British Museum, donated by P. A. Talbot,
Ethno: 1950.Af45.333

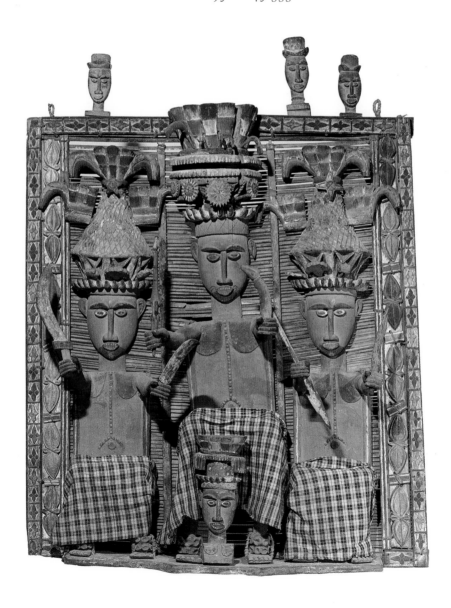

This figure depicts a house head wearing a top hat with the feather of the vulturine fish eagle in the band, the insignia of Ekine membership. The figure wears a representation of a coral bead on the throat and has traces of a painted beard. Ears are carved integrally. The figure wears a wrapper of plush textile.

Central Figure from an Ancestral Screen

Wood, pigment, textile

38 × 9.5 × 13 in. (96.5 × 24.1 × 33 cm)

British Museum, donated by P. A. Talbot,
Ethno: 1950.Af45.338

This is the largest screen. The museum's register entry for this piece reads: "An idol or fetish of carved and painted wood, used in ancestor worship. The figures are supposed to represent the Father, son and grandson. Foochi, New Calabar, West Africa." No information about J. Newall Thomson, the donor, is known.[87]

Informants in both New Ifoko and Bakana (with its subsection Fuchee, see note 41) identified this as an Ifoko screen but were unsure of its identity. In Ifoko, the identification was made on the basis of its alleged similarity to a statue formerly in the shrine of Amaningio, brother of Owamekaso and deity of the river pilots. This was described as being very large and featuring a white man on a bicycle.[88] In Bakana, the piece was attributed to Ifoko because it showed woodworking skills only available there.

Except for the two small figures at the inside top that wear Otobo masks, all the figures were identified as wearing Alagba headdresses. They incorporate carved wooden tassels suspended by wire. All main figures bear carved tusks and flanking figures carry the Alagba sword. All wear resist-dyed *alu* cloth on the forehead.

Stylistically, this screen is unusual in that it is far more naturalistic than the others, as evidenced by the modeling of the facial features and the roundness of the chests and abdomens. The tops of the arms and legs are carved from the same block of wood as the torso. Only the central figure has a beard and mustache, which might suggest that flanking figures are intended to be shown as juniors. All have painted eyebrows and wear rattle leg bands.

Despite being the earliest screen to enter Western collections, it is tempting to ascribe a relatively recent date to this piece in accordance with the underlying trend toward naturalness in more modern or imported Kalabari forms. The most striking feature of the screen is its depiction of smiling figures, unique in the corpus of known *duein fubara*. Although this might be interpreted as indicating the influence of photography, old Kalabari "snaps" do not show people who are smiling. This Western photographic convention has only been imported to Kalabari relatively recently. It does suggest, however, iconographic influence from the West in some form, which is also evident by the evolution of the heads at the top of the screen into miniature "busts."[89] Given the Ifoko attribution, the possibility is raised that people of that village continued to make screens for their own use after the practice had been discontinued elsewhere.

Even the use of social perspective is attenuated in this screen—the figures have a greater air of equality than in the other *duein fubara*. This led one informant to tentatively suggest that it might be the screen of Dokubo-Ye-Ekine, who had two particularly capable fellow chiefs.

Ancestral Screen (*Duein Fubara*)

Wood, split vegetable fiber, pigment
61.5 × 39.5 × 15 in. (156.2 × 100.3 × 38.1 cm)

Glasgow Museums and Art Galleries,
donated by Mr. J. Newall Thomson in 1900, 00–141a

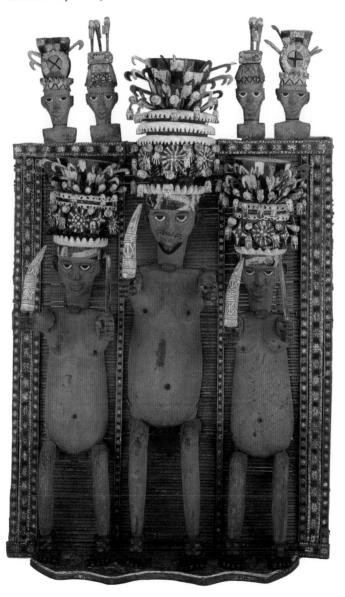

T he museum's record for this screen reads:

> *Nduen fobara* (Ancestral Image). Image of a KALABARI Chief with two
> supporters mounted on elaborate screen, the whole carved and painted and
> forming the chief feature of an ancestral shrine in a KALABARI house.
> These images can only be made by the Pokia family, living at IFAWKAW
> (FOUCHE). Into the figures the spirits of ancestors are thought to enter and
> to listen to the prayers of their descendants. Sacrifices are made to them
> every eighth day. The central figure represents the Chief in whose memory
> the monument was raised, the figures on either side are two of his chief
> servants, and the heads at the top are secondary attendants. The small image
> between the Chief's legs is said to represent the slave formerly sacrificed at
> the funeral. Human sacrifices were forbidden after the arrival of the dominant
> KALABARI juju Awome-ka-so.

This is another screen featuring the Alagba masquerade. As illustrated in
Talbot 1916, the screen includes a small figure between the feet of the central
figure and two chickens on the baseboard. These are now lost. Decorative features
are attached with metal loops. Many have been lost, leaving the loops exposed.
The center figure carries an inverted single gong. The figure to the right of the
screen holds a cane. The figure on the left has a fan in his right hand. All are
dressed in imported cloth wrappers.

Ancestral Screen (*Duein Fubara*)

Wood, split vegetable fiber, pigment, textile
38 × 33 × 15 in. (96.5 × 84 × 38 cm)

Pitt Rivers Museum, Oxford,
donated by P. A. Talbot, 1916.45.183

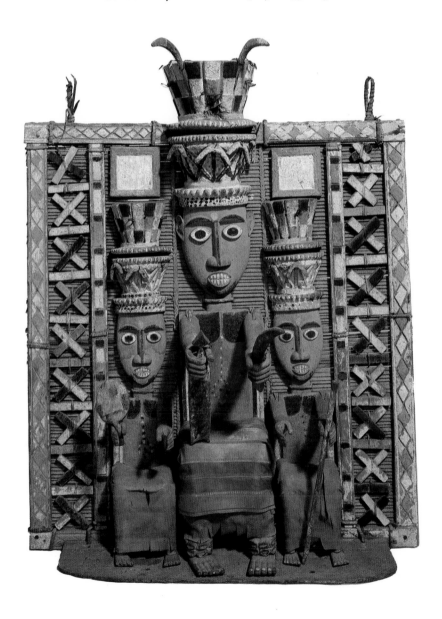

This screen, like a number of others, portrays the Alagba masquerade. Each flanking figure wears a top hat with the feather of the vulturine fish eagle, signifying membership in the Ekine society.

The frame is decorated with stylized cowrie shells. The central figure carries a wooden paddle in one hand and a carved tusk in the other. On the left arm is a bracelet of small metal bells incorporating a glass bead known as *ela*. The figure on the left of the screen holds a tusk in the right hand; the object in the left hand is unidentifiable. The figure on the right of the screen holds a cane and a fan.

Ancestral Screen (*Duein Fubara*)

Wood, split vegetable fiber, pigment
46 × 31 × 13 in. (116.8 × 78.7 × 33 cm)

Pitt Rivers Museum, Oxford,
donated by P. A. Talbot, 1916.45.184

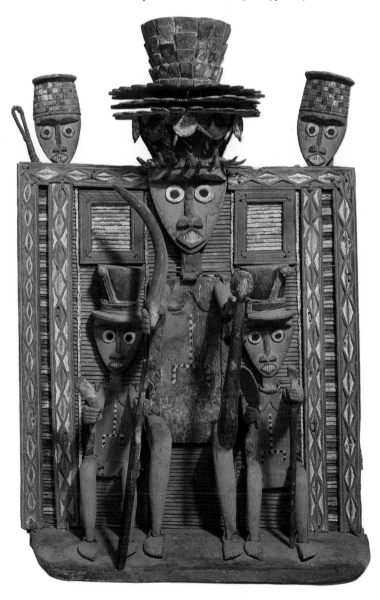

This screen features the Alagba masquerade. It is therefore insufficiently distinctive to allow identification. The only helpful feature is the incorporation of the letters *DP* at various points on the frame. This presumably refers to the Don Pedro house, which was part of the Barboy group. During the Kalabari civil war period, the house was split between Bakana and Abonnema. The screen could therefore be from either town.

The flanking figures wear either Sansun hats or knitted caps. Nowadays the Sansun hat, made of bamboo and cloth, is regarded as the prerogative of powerful priests (see cat. no. *5*).

Ancestral Screen (*Duein Fubara*)

Wood, split vegetable fiber, pigment
37.5 × 28 × 9.75 in. (95.3 × 71.1 × 24.8 cm)

Minneapolis Institute of Arts, 74.22 (formerly in the
British Museum collection, donated by P. A. Talbot)

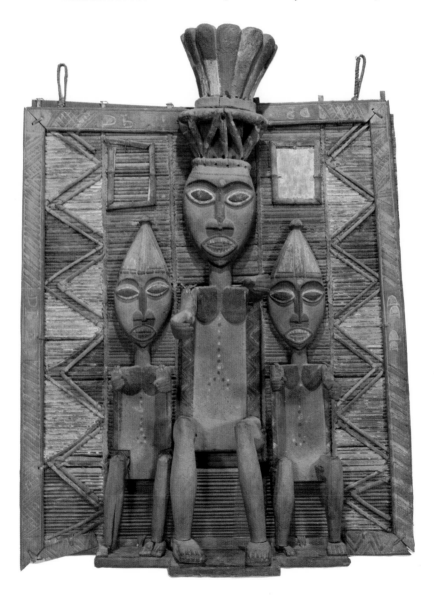

Notes

Introduction

1. The contemporary artist Eduardo Paolozzi, for example, has produced works inspired by the Kalabari screens.

2. The hostility between the settlements goes back at least to the Kalabari civil war of the late nineteenth century and is not reducible simply to that between pagan and Christian. Some of Garrick Braide's most implacable adversaries in Buguma, such as Chief Sokari George, were Christians. As one informant put it, "In the Bible they ask, 'What good ever came out of Galilee?' In Buguma they say the same about Abonnema and Bakana."

3. For details, see Talbot 1916 and Johnson 1916.

4. A number of people in Kalabari have been named after Talbot. He also has an enduring reputation for severity. One local man remarked, "If a lizard walked into the room where his wife was having a bath, Talbot would put that lizard in jail."

5. I have pointed out elsewhere that mass rejection of previously accepted cults is a recurring feature of Kalabari religious life (Barley 1987, 371). Cults tend to be rejected not because of their ineffectiveness but because they are excessively powerful and have gotten out of control. The renunciation of the *duein*

fubara may fit this model, coming as it did on the heels of the repeal in 1915 of the British Native House Rule Ordinance, which had reinforced the authority of the house heads.

Foreheads of the Dead: An Anthropological View of Kalabari Ancestral Screens

6. Horton (1965a, 1) numbers twenty-two Kalabari villages and three towns scattered over an area of nearly a thousand square miles.

7. It should be stressed that farming is a secondary activity, found primarily in non-Buguma areas. In the original New Calabar settlement, dry land would have been much scarcer. In Buguma, it is still considered a serious offense to grow yams within the town boundaries; cultivation is limited to plantations. That this prohibition was maintained in the original settlement is stated by Smith (1851, 133).

8. Old Calabar, an Efik trading settlement far to the east on the Cross River, and New Calabar are often confused. The reason for the similar names has yet to be conclusively explained.

9. One of the constant sources of friction between European traders and the Kalabari was the insistence of the latter that any agent trading at Bonny could not also trade at New Calabar, thus obliging firms to maintain separate establishments at both places.

10. A major new import at this time was Cheshire salt. Local salt production virtually ceased.

11. Indeed, sometimes the same people were involved, for example, the trader Cyril Punch. Traders, moreover, could be appointed to represent British government interests in the days of the Niger Coast Protectorate. For the flavor of the trader's life in the Niger Delta, see Cole 1862, Hutchinson 1858 and 1861, Leonard 1906, Smith 1851, Ellis 1883.

12. Horton has forcefully argued the case that the Kalabari were able to extend their period of prosperity into the 1920s and 1930s by skillful domination of the upstream Oguta markets. In earlier times, they also seem to have been aware of the vulnerability of their position. Ellis (1883, 114) remarks concerning the Niger Delta:

> Very little is known of this part of Africa beyond the actual coast line and the Niger river, up which steamers ascend for some hundreds of miles. Between Benin and the Nun mouth the numerous Western outlets have not even been surveyed, and we find on the Admiralty Charts "natives hostile and cannibals." In that portion of the delta the inhabitants will hold no friendly intercourse with white men. Even in those rivers in which the trading hulks are moored, Europeans are prevented by the chiefs from ascending the streams; and in the different treaties there is generally a stipulation that the traders shall not attempt to go beyond a certain distance. The reason for this is that the tribes that reside near the mouths of the rivers act as middle-men to the native oil-traders

higher up, and they are afraid that if we penetrate beyond a short distance we shall be able to purchase the product at first hand, and that they will thus lose their percentage or commission.

13. This should not be regarded as the only source of new members. The trading polities of the Niger Delta acted as magnets for the young and ambitious who came to seek fame and fortune.

14. Hutchinson (1861, 191), a British consul for the area, remarks:

> The prices at which European articles are pressed upon them in the first instance are unnecessarily exorbitant, in order to admit of a profit to the British adventurer, who thus intrusts his property to a native about to set off to the interior in search of native produce, with which, after a lapse of one or two years, he may or may not return to discharge his debts. The only security of which the supercargo can avail himself in such circumstances is to place so high a nominal value on the goods which he advances, as may protect his employers against partial default, and cover not only the risk but the actual cost of shipping long detained in the rivers to await the returns from the speculative investments, with all the incidental charges for interest of money, insurance, depreciation, commission, wages and outlay on the crews. It is not to be wondered that the native debtor, aware of the disadvantageous terms on which he had originally contracted his engagement, on returning to the coast, and bringing with him the articles collected on his long circuit in the interior, should hesitate to deliver them to the creditor, and should yield to the bait of better terms offered by a rival European agent.

The trading system is described firsthand by Smith (1851, ch. 19).

15. One of the problems with the accounts given by European travelers and traders is that they employ pidgin concepts such as "fetish" and "juju" that correspond to very little in the categories of the locals. Their use is simply a mark of there being something that seems strange to Westerners.

16. For a survey of these conflicts, see Jones 1963. Basically, it is the story of the personal struggle between the energetic house head Will Braide and the powerful George Amachree.

17. In New Calabar, such a flexible system of marriage allowed a house to increase its membership through marriages of both its male and female members. A favored male slave, for example, could be married to a daughter of the house head in *egwa* marriage. The children of the marriage were then full members of the house through their mother. Male members could make *eya* marriages with outside women and so acquire rights over children by them.

18. Masquerades are not generally expected or required to bring benefits to the living. Horton (1963, 96) remarks:

> In short, *Ekine* as a cult group is principally devoted to marginal and even obnoxious gods whose only service to men lies in ensuring the success of the plays that represent them.

19. It would be wrong to overstate the degree to which Kalabari engage in a theoretical dissection of human powers. Often, bilingual Kalabari will translate *fubara* as "image."

20. See Horton 1965a, 8, or more fully Horton 1960a, 1963.

21. The translation of terms such as *so* and *tamuno* is notoriously difficult, especially since our language makes it impossible to do so without importing our own notions. Horton (1984) has argued strongly against the use of "Judaeo-Christian spectacles" in the act of translation. Such identifications, however, have a mnemonic value for those new to the intricacies of Kalabari spiritual concepts and are acceptable in a general publication.

22. For example, Horton 1963, 1965a, and Horton and Finnegan 1973.

23. The making of *duein fubara* having been recently resumed, it seems appropriate to use the ethnographic present in speaking of them.

24. The relationship between a man and his name and that of a spirit and its mask is explored by Horton (1965a, 10).

25. While in Kalabari, I was allowed to visit the shrine of Amaningio, the Ifoko god of the river pilots, but I was advised against seeking to enter the shrine of Owamekaso. According to Tasie (1977, 27), the first non-Kalabari to enter this shrine was Talbot. See, however, de Cardi 1899, 506, and Waddell 1863, 420.

26. This raises the question of whether the *duein fubara*, nowadays a mark of the traditional social order, may not once have been somewhat revolutionary and associated with the decline of the old houses and the rise of rich new groupings led by slaves and sons of slaves.

27. This remark only applies to the standard corpus of established carvings. Outside this area, Kalabari have shown a zestful appetite for adopting non-Kalabari masquerades from neighboring peoples that fully matches the appetite they have shown for Western visual forms.

28. See discussion, p. 16.

29. This point has been stressed by Tonye Erekosima in a personal communication.

30. Even today, Kalabari are much concerned with the notion of bad death. Suicide or an illness involving swollen feet (a mark of being a sorcerer) are foremost examples of bad deaths. Such people may not be accorded a normal burial and are flung into the mangrove swamps to be devoured by wild beasts. Both ends attributed to Garrick Braide are bad deaths.

31. This tripartite construction is common to the screens here but far from universal in Buguma. The screen of Amachree I, for example, has five main figures (fig. 10, p. 30). Asymmetrical screens are certainly known, though they may have been reconstituted from more than one original. An interesting fact about asymmetrical screens is that several figures within the screen may be interpreted as the same individual in different roles.

32. As one informant expressed it, "These [Alagba] screens are like photographs of your grandfathers. You cannot recognize them unless you have been *told* they are your grandfathers. You cannot recognize the picture of someone you do not know."

33. There is no suggestion that anyone, including women, should be unaware that the masquerade costume contains a man. They should not know *which* man.

34. There are some exceptions to this. Branch houses may have no meetinghouse of their own, or nowadays the meetinghouse may have fallen into disrepair. In such cases, the screens are often found in separate corrugated-iron shelters.

35. Kalabari women doubtless have strong influence on the conduct of house affairs, but this should always occur "behind the scenes." Horton (1969) has discussed the ways in which they may enter vicariously into male pursuits and set up limited parallel systems of status through interaction with minor spirits.

36. In practice, this rarely happened, because houses were more likely to split than amalgamate. Jones (1963, 209), however, documents the case of the Prince Fubara house. It was absorbed by the Horsfall section of the Manuel house, where their screen is now displayed.

37. Offerings of gin or schnapps are the normal practice. The most powerful screens may only receive imported brands. In rich houses this may occur every four or eight days.

38. Within the Kalabari ritual cycle is a special period for ancestral rituals. It is at these that *duein fubara* come to the fore.

39. People who have no house descendants are held to be particularly unfortunate and spiteful.

40. This probably means no more than that the Kalabari ritual cycle should have completed the period devoted to masquerades and water spirits and returned to a phase of ancestral concern.

41. During the Kalabari civil war of the late nineteenth century, many of the inhabitants of Ifoko, the town that supplied river pilots for European ships, moved near Buguma and called their town New Ifoko. Others moved to an area in Bakana, where, to avoid causing confusion from use of the name Ifoko, they adopted the name Fuchee. Fuchee had been a European variant of Ifoko.

The Ifoko origin of *all* of the screens is unclear. It is confirmed by inhabitants of New Ifoko, but some informants from other towns maintain that screens could be

made in other places as well. It seems clear, however, that the best woodworkers were held to be in Ifoko, where there had been the greatest contact with European carpentry skills. Jones (1963, 144) records a complaint of British traders in the 1850s that Kalabari carpenters had mastered the art of coopering and were engaged in changing the sizes of barrels used in the oil trade. This allegation is confirmed by Smith (1851, 201). At what date woodworking skills might have been passed on is unclear. The 1850 establishment of Charles Horsefall and Co., after which Horsfall house is named, included European coopers and other craftsmen. By 1873, there were no longer any European craftsmen (Jones 1963, 74–75).

42. The same type of ritualized conflict occurs between the family of the husband and that of an *eya*—or high brideprice—wife on the wife's death.

43. This arrangement has been extended to the modern building that houses the Buguma council of chiefs. Here, the framed photographs of the city's founding fathers are displayed around the walls of the chamber.

44. Some houses maintain a usage whereby those making offerings are marked on the forehead and arm with chalk. Warriors about to depart for war might also be marked with dust from the shrine of the national deity Owamekaso, despite her opposition to bloodshed.

45. The white cloth on which offerings are made recalls that on which the first offering is made to a water spirit. Later, it is worn around the stomach of the masquerader. White-cloth shrines occur elsewhere in association with water spirits (Tasie 1977, 9), and white cloths are worn by priests (see cat. no. 5). On the use of cloth at funerals, see Eicher and Erekosima 1987.

46. The royal screens of Amachree I and Amachree III are housed in a temporary accommodation during rebuilding of the Buguma town hall. They have no *otolo*. The most important element of the Amachree I shrine is not the screen, which may be touched, but the sacred *ofo* medicine bundle in front of it, which may not (fig. 10, p. 30). It was on this bundle that Amachree I and the Kalabari people are said to have sworn an oath of mutual loyalty when Amachree assumed the kingship.

47. The history of these manillas can be traced back at least to the eighteenth century, when they were mentioned by Barbot:

> The English and Dutch import there a great deal of copper in small bars round and equal, about three feet long, weighing about a pound and a quarter, which the Blacks of Calabary work with much art, splitting the bar into three parts, from one end to the other, which they polish as fine as gold, and twist the three pieces together very ingeniously, like cords, to make what sorts of arm-rings they please. (Jones 1963, 39)

48. A full discussion of these rites would go far beyond the present purposes of this book. One interesting feature, however, is that the man making the offerings exits from the shrine with a knife in his right hand, a ram's head in his left, and a rooster's head in his mouth. He is praised, however, as a successful hunter of human heads. The *akuma* drum, associated with head-hunting or the "strong" gods who required human victims, is played. Nowadays, such gods receive a dog.

49. It is a recurrent theme of Kalabari religious life that spiritual beings gather strength through their worshipers. Horton (1965a, 8) remarks, "If a spirit becomes too violent, they will tell him the stick they carved him with [that is, which piece of wood they carved his image from]." Hence the effectiveness of mass renunciation. Horton (1960a, 16) cites a case in point:

> Fervent worship will add to a god's capacity to help the worshippers; and just as surely the cutting-off of worship will render the god impotent or at the very least cause it to break off contact with erstwhile worshippers. This fact has more than once been used to put an end to the influence of a god which has started to act maliciously towards its congregation. In one case during the last century, the Owome city-state practised regular cult of a Water Man known as Owu Akpana who materialised from time to time in the form of a great shark. After an unusually large number of people had been eaten by sharks in a short space of time, diviners laid the blame on Owu Akpana and the council of chiefs decided they must put a stop to his unwelcome attentions. To do this, they had a shark caught and its blood poured into the village well. Everyone was then ordered to drink of the water and this symbolic act of communal rejection was allegedly sufficient to destroy the god's power either for good or ill.

On this, see also Hutchinson 1861, 45. In addition, it is clear that a similar model characterized Kalabari secular life, where success was self-sustaining.

50. An interesting feature of this screen is that the carver painted it with red *awo*, otherwise painted on the body of a woman the first time she gives birth. The house head said that at the next ancestral festival it would be repainted with more conventional colors.

51. This aspect of Niger Delta culture impressed Western traders but was typically interpreted as showing the deceitfulness of the locals.

52. Kalabari informants can be unnervingly precise in answers to questions about chronology. Asked when the first European traders came to Kalabari, one informant immediately replied, "The eleventh of November 1192."

53. On grounds of purely relative chronology, other candidates suggest themselves, for example, Seleye Fubara. See Horton 1965a, pl. 5.

54. In a personal communication, Tonye Erekosima has pointed out to me the central importance of the head in Kalabari culture, both as the seat of *teme*, or spirit, and as a focus of the elaboration of rules of respect.

55. Barbot (1746, 460) remarks concerning a visit to New Calabar:

> The twenty-fourth, I came before the town of [New] *Calabar*, and fired three guns, to salute the king; after which I made him the usual presents of one cask of brandy, and a barrel of powder, with a hat.

That trade in Western wear occurred at a less formal level is also revealed by Barbot (1746, 462):

> There is a prodigious number of monkeys and apes about *Calabar*, but not handsome. They have also blue parrots. The natives give three or four monkeys for an old hat or coat, taking much pride to dress themselves in our sailors old rags.

56. Thanks are due to Ms. Avril Hart of the Victoria and Albert Museum for information regarding hats.

57. Small heads are, of course, detachable and so may not be of the same date as the main screen. These, however, appear to be by the same hand as the larger figures.

58. The three-legged pot relates to a myth in which Owamekaso owes her preeminence as goddess to the fact that she alone was able to remove a hot cooking vessel from the fire.

59. A plant called *birin ogu*, or "Igbo leaf" (*Telfairia occidentalis*), must also not be carried across the market or brought near the goddess on account of its putative Igbo associations. Horton informs me that this is not the plant described by Tasie (1977, 22) as "the ferns growing on the tower of the church as an evidence of Akaso's [Owamekaso's] continuing existence in the town [Abonnema]." The latter is a fern of the saltwater margins known as *imingeye*.

Other deities besides Owamekaso, such as Opu Adumu, have cloths associated with them (Horton 1965a, pl. 17).

That the prohibition against wearing cloth depicting figures or flowers broke down is evidenced by a photograph of Amachree IV. The photograph, plausibly said to have been taken in the late 1880s, was much used in the recent Buguma centenary celebrations in 1984. It shows the king seated on a chair covered with a textile that depicts large flowers.

60. Thus, the well-documented Asante "museum" (McLeod 1987). It has been argued that the Asante approach to socially disruptive goods was to remove them from circulation and keep them in storage.

61. It is possible that Owamekaso has been influenced by the ubiquitous Mammy Wata cult, which is likewise associated with canoes, snakes, and pale skin. Informants, however, associate the Mammy Wata deity with the hinterland. It has been suggested that the figureheads of Western ships may have been an important source of the iconography of this deity. (Until the 1930s, a figurehead from a ship was preserved at the Degema Consulate,

an area where Europeans lived.) For the influence of a popular print, see Salmons 1976.

The Talbot collection in the Pitt Rivers Museum, Oxford, contains a carving (1916.45.162) said to be Owamekaso and given an Abonnema attribution. It looks much like any other hero sculpture (see, for example, Horton 1965a, pl. 12).

Further information on this shrine is available from Hutchinson (1858, 102):

> Every great man in New Kalabar has a ju-ju house of his own, and the varieties of carving in ivory and wood to be seen in these heathen temples are grotesquely savage indeed. Inside of Amakree's there are four large tusks carved to represent human figures, each one supposed to preside over its particular ju-ju dwelling place. As at Brass, there is an excavation in the ground, in the centre of three figures, about a yard in circumference, in which solid offerings are deposited, and around this cavity, which is supposed to be the deity's residence, are erected four mud-grey cones with a hole in the top of each, into which wine, rum or palm-wine is poured as oblations to suit the different motives for sacrifice.

62. Thus, when Frobenius (1913) "discovered" the Ife bronzes, he immediately assumed he had found remains of a Greek colony in Africa. When Read and Dalton (1890) came to write of the origins of Benin brasscasting, it seemed obvious to all that the Bini had been taught by the Portuguese.

It would be similarly unnecessary to relate the development of the canoe house itself to the prototype of the European trading house. These were institutions of very different kinds. Yet, it may be imagined that the possibility of translating one structure into another appealed to Niger Delta people. Thus, for example, the exchange between Smith (1851, 196) and a West African trader:

After rating a great man for being so tardy in meeting his payments, he called me a "white nigger" [in pidgin, *nigger* was a term used for a man who was under the command of another] as a set off for my having called him a "black nigger." "What way" said I, "you call me a nigger. I be free man. I be gentleman in my own country." [In pidgin, *gentleman* was a term for one who commanded others.] "Chi," said he. "What way you call yourself gentleman? Who them ship belong for? He be yours?" "No," I replied, "the ship is not my property." "Well then, you be white nigger, suppose you no be nigger, you bring your own ship and no 'tother man's ship."

63. Even nowadays a common Kalabari ritual meal is ship's biscuit and bully beef washed down with weak milky tea.

64. The pattern of European contacts varied over time. In early periods, vessels would simply arrive on an ad hoc basis and wait for a cargo of slaves to be collected. The normal practice would be to roof over the vessel and ride out the wait at Ifoko for the necessary three months or so. It took much longer, however, to collect a cargo of palm oil—on average over five months. From the 1850s, therefore, it was typical for European trading houses to have a permanent agent residing on a "hulk" (a dismasted, beached vessel) to collect oil for later dispatch. With the advent of regular steam shipping, there was a drastic decrease in the number of vessels calling at the ports. The European population of New Calabar in 1862, including visiting sailors, was 278. By 1873, the European population of the entire Oil Rivers area had dropped to 207 (Jones 1963, 74).

Although the extent of European influence is immediately obvious, it must be remembered that large numbers of workers from other parts of West Africa—especially Kroomen from Cape Palmas, Liberia—were imported by European traders. It remains to be seen what their contribution to Kalabari culture might be.

65. See, for example, Jones 1963, 31.

66. It is not clear when the Benin plaques were removed from the pillars of the royal palace and placed in storage, where they were found by the British punitive expedition of 1897. It is possible that they may not have been publicly visible after the late eighteenth century.

It should be noted that current research on Benin plaques is hampered because Bini modes of perception have been as surely transformed by the influence of the West and the camera as those of Kalabari. Bini now speak of the brass plaques as if they were photographs of court life. The identification becomes complete in the plaque cast to commemorate the visit of Queen Elizabeth II to Benin. The casting was made from a photograph and includes its frame within the casting.

67. When the effects of the Europeans killed in the Benin massacre were recovered in 1897, for example, cameras were among them (Roth 1903, xii).

It remains the case that cast brass objects have been found in the Kalabari area (Horton 1965b). However, the status of Benin as *the* center of brasscasting is now so undermined that this carries little weight in terms of possible historical links.

68. See Sprague 1978.

69. Personal communication from Sokari Douglas Camp.

70. It is interesting to note that when speaking of spatial relationships within both screens and photographs, Kalabari refer to the left of the image as "on the right," that is, they put themselves in the positions of the figures in the image.

Catalogue Raisonné

71. It might be thought that social perspective represents a powerful argument against the influence of Western naturalism in the screens and strengthens the case for inspiration from Benin. Part of the social perspective of the Benin plaques is spurious in that smaller figures are, in fact, page boys of the court. In the cases where it is genuine, the social perspective of Benin is far more extreme than that of Kalabari; minor figures are used in an almost diacritical fashion.

The relative largeness of the central figure of a Kalabari screen strengthens those interpretations that make a link between the three human forms and the three mud pillars (*otolo*) that are the main part of the ancestral shrine. The central pillar is generally larger than the other two.

72. This also happens in the field. During questioning in Horsfall house, Buguma, I drew attention to remnants of a screen decaying in one corner. While discussing it, one of the members of the house withdrew an intact small figure from the pile of pieces and added it to the main *duein fubara* of the house.

73. In a personal communication, Horton writes, "For some masquerades, the player, before going out, goes to the shrine of Ekineba, patroness of the society. There Ekine Alabo [priest of the Ekine society] pours a libation and dabs some of the damp earth (*anwo*) on his chest and forehead. I can't recollect offhand whether he also puts kaolin. But it would be in keeping."

74. A barracoon was a large shed, usually built of stone, in which slaves were kept while awaiting shipment.

75. Concerning Barboy, Hutchinson (1861, 172) comments:

> Up New Kalabar river King Amakree may be said to be the undisputed reigning head, although held in check socially by the superstitious tomfoolery of a ju-ju king, named Akoko . . . and commercially by a family named Barboy, who are first-class traders and believed by some persons to have a presumptive right to the monarchy of New Kalabar.

76. In Kalabari, the head is a focus of individuality and must be respected. This is linked with cultural practices as diverse as head-hunting and the elaboration of headgear. It was a mother's prerogative to shave the heads of her children and slaves. To shave the head of a rival was thus to humiliate and subordinate him.

77. One of the praise names of Odum is "He who rests his feet on skulls."

78. Talbot (1926, 488) remarks concerning the dead:

> For those who had visited the Aro Chuku oracle or were members of the [head-hunting] Peri Club, chalk is rubbed up the right arm and a manilla placed around the right wrist, on which feathers and blood from sacrificial fowls are smeared, while an eagle's feather is fixed in the hair.

Unfortunately, it is impossible to establish the original gradations of body color shown in the screen.

79. Abonnema is only several minutes by canoe from Degema Consulate, where Talbot would have lived.

80. This, for example, is the interpretation offered of the screen of Oro Moni of Jack Rich house. He similarly wears a top hat.

81. After such a long time, we cannot tell how much Kalabari funerary practices may have been affected by those of European traders. For example, Bindloss (1898, 221) somewhat diffidently relates:

In all the swamps of the steamy delta the rough deal cases in which long-Dane guns are shipped are used as coffins, and they are sometimes a trifle too short. In seasons of unusual pestilence—so at least the story goes, and stranger things are done—there is no time to lengthen them for a man above the average stature. Then the end would be knocked in, and if the head of the occupant projected beyond it in an unseemly fashion an old silk hat was nailed across.

82. See discussion of figurative designs and Owamekaso, p. 34.

83. Jones (1963, 70) further specifies that a candidate must belong to the former Korome ward. It seems likely that this was the ward that supplied the king in the days before the Amachree dynasty and probably reflects a common pattern in African history whereby deposed dynasties nevertheless maintain ritual powers.

84. Real India is a type of checked cloth formerly imported from Madras, India.

85. *Ikaki* is an Igbo cloth from Akwete bearing a tortoise motif.

86. Seven Alagba headdresses are involved in any one performance. The Otobo masquerade follows on the next day.

87. The date of Mr. Thomson's gift makes the screen the earliest to have come to the West. Although it was accompanied by other material from the Niger Delta, the major part of the Thomson collection is composed of natural historical material from the Bahamas. The possibility exists that the screen had been in Scotland for some time prior to the donation. Ms. Antonia Lovelace of the Glasgow Museums and Art Galleries remarks in a personal communication:

> His [the donor's] name was replaced by that of his widow in the Post Office Directory for their address in 1903, so this was either a gift of his last years or a bequest.

The full importance of this screen was only recognized in 1978 by then assistant keeper of ethnography, Tess Gower. After careful restoration by the department's conservation workshop, under Mr. W. Ross, the screen was put on display in 1979.

88. The Talbot collection of the Pitt Rivers Museum, Oxford, includes a curious paddle incorporating an Otobo mask and a human head (1916.45.161) that is said to be from this shrine. The register notes that it is the sole surviving sculpture of this origin; the rest were destroyed by Garrick Braide.

89. See also the figure pegged into the baseboard of catalogue number 8.

Bibliography

Alagoa, Ebiegberi Joe. 1971. "The Niger Delta States and Their Neighbours to c. 1800." In *History of West Africa*, vol. 1, edited by J. F. Ade Ajayi and Michael Crowder. London: Longman.
———. 1972. *A Short History of the Niger Delta*. Ibadan: Ibadan University Press.

Barbot, Jean. 1746. *A Description of the Coasts of North and South Guinea and of Ethiopia Inferior Vulgarly Angola*. London.

Barley, Nigel. 1987. "Pop Art In Africa? The Kalabari Ijo Ancestral Screens." *Art History* 10 (3): 369–80.

Ben-Amos, Paula. 1980. *The Art of Benin*. London: Thames and Hudson.

Bindloss, Harold. 1898. *In the Niger Country*. Edinburgh and London: William Blackwood.

Boston, John. 1977. *Ikenga Figures among the North-West Igbo and the Igala*. London: Ethnographica.

Case, Juli. 1987. "Western Influence on Kalabari Men's Dress." Undergraduate Research Opportunities Program, Department of Design, Housing and Apparel, College of Home Economics, University of Minnesota. Photocopy.

Cole, William. 1862. *Life in the Niger, Or Journal of an African Trader*. London: Saunders, Otley.

Crow, Hugh. [1830] 1970. *Memoirs of the Late Captain Hugh Crow of Liverpool*. Reprint. London: Cass.

Crowther, Samuel, and James Frederick Schoen. 1842. *Journals of the Revd. James Frederick Schoen and Mr. Samuel Crowther*. London: Hatchard.

Curtin, Philip. 1971. "The External Trade of West Africa to 1800." In *History of West Africa*, vol. 1, edited by J. F. Ade Ajayi and Michael Crowder. London: Longman.

Dapper, Olfert. 1686. *Description de l'Afrique*. Amsterdam: Wolfgang, Waesberge, Boom and van Someren.

de Cardi, Charles Napoleon. 1899. *A Short Description of the Natives of the Niger Coast Protectorate*. Appendix 1 in *West African Studies*, by Mary Kingsley. London: Macmillan.

Dike, Kenneth. 1956. *Trade and Politics in the Niger Delta*. Oxford: Clarendon Press.

Eicher, Joanne, and Tonye Erekosima. 1982. *Pelete Bite: Kalabari Cut-Thread Cloth*. St. Paul, Minnesota: Goldstein Gallery, University of Minnesota.
———. 1987. "Kalabari Funerals: Celebration and Display." *African Arts* 21 (1): 38–45, 87.

Ellis, Alfred Burdon. 1883. *The Land of Fetish*. London: Chapman and Hall.

Fawckner, James. 1837. *Narrative of Captain James Fawckner's Travels on the Coast of Benin, West Africa*. London: Schloss.

Foss, W. Perkins. 1975. "Images of Aggression: Ivwri Sculptures of the Urhobo." In *African Images: Essays in African Iconology*, edited by Daniel McCall and Edna Bay. Boston University Papers on Africa, vol. 6. New York: Africana.

Frobenius, Leo. 1913. *The Voice of Africa*. London: Hutchinson.

Horton, Robin. 1960a. *The Gods as Guests: An Aspect of Kalabari Religious Life*. Nigeria Magazine Special Publication no. 3. Lagos: Nigeria Magazine.

———. 1960b. "New Year in the Delta." Nigeria Magazine 64:258–95.

———. 1963. "The Kalabari Ekine Society: A Borderland of Religion and Art." *Africa* 33:94–114.

———. 1965a. *Kalabari Sculpture*. Lagos: Department of Antiquities.

———. 1965b. "Duminea: A Festival for the Water-Spirits in the Niger Delta." *Nigeria Magazine* 86:187–98.

———. 1966. "Igbe: An Ordeal for Aristocrats." *Nigeria Magazine* 90:226–39.

———. 1969. "Types of Spirit Possession in Kalabari Religion." In *Spirit Mediumship and Society in Africa*, edited by John Beattie and John Middleton. New York: Africana.

———. 1970. "A Hundred Years of Change in Kalabari Religion." In *Black Africa*, edited by John Middleton. Ontario: Macmillan.

———. 1984. "Judaeo-Christian Spectacles: Boon or Bane to the Study of African Religions?" *Cahiers d'études africaines* 96:391–436.

Horton, Robin, and Ruth Finnegan, eds. 1973. *Modes of Thought: Essays on Thinking in Western and Non-Western Societies*. London: Faber and Faber.

Hutchinson, Thomas. 1858. *Impressions of Western Africa*. London: Longman.

———. 1861. *Ten Years Wandering among the Ethiopians*. London: Hurst and Blacker.

Johnson, James. 1916. "Elijah II (Garrick Braide)." *Church Missionary Review* 67:455–62.

Jones, G. I. 1958. "Native and Trade Currencies in Southern Nigeria during the Eighteenth and Nineteenth Centuries." *Africa* 28:43–54.

———. 1963. *The Trading States of the Oil Rivers: A Study of Political Development in Eastern Nigeria.* London: Oxford University Press.

Leonard, Arthur. 1906. *The Lower Niger and Its Tribes.* London: Macmillan.

McLeod, Malcolm. 1987. "Gifts and Attitudes." In *The Golden Stool: Studies of the Asante Center and Periphery,* edited by Enid Schildkrout. Anthropological Papers of the American Museum of Natural History, vol. 65, pt. 1. New York.

Oelmann, Albin. 1979. "Nduen Fobara: Ancestral Memorial Screens from New Calabar." *African Arts* 12 (2): 36–43, 90.

Pacheco Pereira, Duarte. 1937. *Esmeraldo de Situ Orbis.* Translated and edited by George H. T. Kimble. Works Issued by the Hakluyt Society, series 2, no. 79. London: Hakluyt Society.

Read, Charles Hercules, and Ormonde Maddock Dalton. 1899. *Antiquities from the City of Benin and from Other Parts of West Africa in the British Museum.* London: British Museum.

Roth, H. Ling. 1903. *Great Benin: Its Customs, Art and Horrors.* Halifax: King.

Ryder, Alan F. C. 1969. *Benin and the Europeans 1485–1896.* London and Harlow: Longman.

Salmons, Jill. 1976. "Mammy Wata." *African Arts* 10 (3): 8–15, 87–88.

Smith, J. 1851. *Trade and Travels in the Gulf of Guinea, Western Africa, with an Account of the Manners, Habits, Customs, and Religion of the Inhabitants.* London: Simpkin and Marshall.

Sprague, Stephen F. 1978. "Yoruba Photography: How the Yoruba See Themselves." *African Arts* 12 (1): 52–59, 107.

Talbot, Percy Amaury. 1916. "Some Beliefs of Today and Yesterday." *Journal of the African Society* 15:305–19.

———. 1926. *The Peoples of Southern Nigeria.* 4 vols. London: Oxford University Press.

———. 1932. *Tribes of the Niger Delta.* London: Sheldon.

Tasie, G. O. M. 1977. "Kalabari Traditional Religion." *Marburger Studien zur Afrika- und Asienkunde* 9. Berlin.

Waddell, Hope. 1863. *Twenty-Nine Years in the West Indies and Central Africa.* London: Nelson.